WILLIAMSBURG
THROUGH TIME

AMY WATERS YARSINSKE

AMERICA
THROUGH TIME®
ADDING COLOR TO AMERICAN HISTORY

America Through Time is an imprint of Fonthill Media LLC
www.through-time.com
office@through-time.com

Published by Arcadia Publishing by arrangement with Fonthill Media LLC
For all general information, please contact Arcadia Publishing:
Telephone: 843-853-2070
Fax: 843-853-0044
E-mail: sales@arcadiapublishing.com
For customer service and orders:
Toll-Free 1-888-313-2665

www.arcadiapublishing.com

First published 2017

Copyright © Amy Waters Yarsinske 2017

ISBN 978-1-63500-044-3

Typeset in Mrs Eaves XL Serif Narrow
Printed and bound by CPI Group (UK) Ltd, Croydon, CR0 4YY

CONTENTS

Introduction

When President Franklin Delano Roosevelt came to Williamsburg on October 20, 1934, to receive an honorary doctorate degree from the College of William and Mary, he told the throngs gathered to hear him—and to witness the installation of John Stewart Bryan as president of the college—that the first time he visited Williamsburg had been more than twenty years before. "I arrived at Jamestown by boat and started to walk to Williamsburg. I was picked up by an old negro in a horse and buggy and driven over what was then a nearly impassable road from Jamestown to Williamsburg," he recalled. "Then there was no capitol building, there was no Palace of the Royal Governors, there was no Raleigh Tavern. Modern buildings had crept into this historic place, almost to the extent of crowding out the fine old Colonial structures which were still standing." Roosevelt extolled what a thrill it had been to return to the same place and to have the honor of formally opening the reconstructed Duke of Gloucester Street, which, as he told the crowd, "rightly can be called the most historic avenue in America; what a joy to come back and see the transformation which has taken place, to see the capitol, the Governor's Palace, the Raleigh Tavern, born again, to see sixty-one colonial buildings restored, ninety-four colonial buildings rebuilt, the magnificent gardens of colonial days reconstructed—in short to see how through the renaissance of these physical landmarks the atmosphere of a whole glorious chapter in our history has been recaptured. Something of this spiritual relationship," he continued, "between the past, the present and the future was expressed by Sir Walter Raleigh:

'It is not the least debt that we owe unto history that it hath made us acquainted with our dead ancestors; and out of the depth and darkness of the earth delivered us their memory and fame.'

He continued: "I am happy to say that the Federal Government, inspired by the fine vision and example of Mr. [John D.] Rockefeller [Jr.] in recreating Williamsburg, has effectively taken up the preservation of other historic shrines nearby. Six miles to the west of us, we have acquired Jamestown Island and we are now carrying on the necessary archaeological and research work to determine what should be done in the preservation of that hallowed spot. Fourteen miles to the east of us at Yorktown, the National Park Service has acquired many thousand acres of land, and is actively carrying out the restoration of the symbol of the final victory of the war for American independence. When the work at Jamestown, at Williamsburg and at Yorktown is completed," Roosevelt

explained, "we shall have saved for future generations three historic places—the nation's birthplace at Jamestown, the cradle of liberty at Williamsburg, and the sealing of our independence at Yorktown."

President Roosevelt reminded his audience that it was to the College of William and Mary that Thomas Jefferson came in 1760. "Here he studied for two years, remaining five years longer in Williamsburg to pursue the study of law," he told them. "It was here in Williamsburg that he returned, first as a member of the House of Burgesses, then as Governor of Virginia, following Patrick Henry. He lived in the Governor's Palace during his term and later served on the Board of Visitors of William and Mary. It was largely the result of his recommendations that the curriculum of the College was broadened to provide education in law, medicine, modern languages, mathematics and philosophy. No doubt inspired by his reflections on government, human liberty and the necessity of education" he observed, "Jefferson throughout his life was interested in designing a system of education for his state and for the nation. I like to think of him," Roosevelt reflected, "not only as a statesman, but as the enlightened father of American education."

Near the end of his address, Roosevelt offered this prescient and timely minder: "The noble list of those who have gone out into life from the halls of William and Mary is in greater part distinguished because these graduates came to know and to understand the needs of their Nation as a whole. They thought and acted—not in terms of specialization, not in terms of locality, but rather in the broad sense of national needs. In the olden days," he continued, "those needs were confined to a narrow seaboard strip. Later the needs gradually extended to the Blue Ridge and across through the mountains to the fair lands of Tennessee and Kentucky. Later still they spread throughout the great middle west and across the Plains and the Rockies to the Pacific Ocean."

Today, each visitor to Williamsburg, Virginia, takes a step back in time to the small town that for nearly a century was capital of Virginia, one of the most influential of all of England's thirteen American colonies, and the focus of a significant plantation society. Eighteenth-century buildings, furnishings and gardens again take their original form in this historic community. Colonial-period carriages once more clatter along Duke of Gloucester Street, still the most important eight blocks—between Blair Street to the east and Boundary Street to the west—in the United States. This ninety-nine-foot-wide "great street" of Virginia's eighteenth century capital remains one of the few places in the nation that has so effectively used the present to recreate the past as authentically and successfully. Since 1927, when the first preliminary drawings illustrating the restoration of the entire town were completed, and John D. Rockefeller Jr. moved to acquire the first key properties toward restoration of Williamsburg, the American past has been brought to life in an area nearly a mile in length. In this sacred hollow of America's past were enacted some of the most dramatic scenes of our history—and with it some of the nation's most famous patriots and future Founding Fathers. Restoration and discovery continue to be carried out by the Colonial Williamsburg Foundation, a nonprofit organization dedicated to the premise that the future should learn from the past.

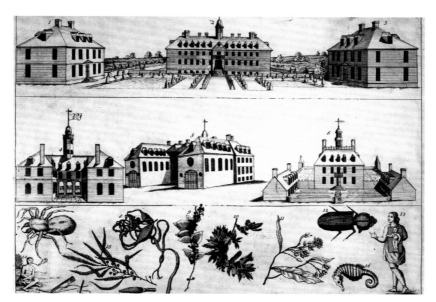

Williamsburg was first settled in 1638 as Middle Plantation, so named for its location on high ground at the centerline of the Virginia Peninsula and some distance from both the James and York Rivers. But near the town, College Creek and Queen's Creek each fed into one of the two rivers. A defensive palisade, finished in 1634, was an important part of Middle Plantation, and though the exact route of it has long since disappeared from the landscape, later archaeological excavation revealed remnants of the palisade on the Bruton Heights School property. This print from the original copper plate depicting the colonial architecture of Williamsburg, Virginia, and discovered in the Bodleian Library at Oxford University, was critical to the reconstruction of Williamsburg in the early- to mid-twentieth century. The print is possibly the work of John Bartram, a colonial botanist, and depicts two rows of buildings, the College of William and Mary at the top, and the early Virginia capitol building and Governor's Palace on the second row. The third row depicts plant specimens, insects, and two views of Native American indigenous people as well as tools that they used. *New York Public Library*

From an original portrait by Sir Peter Lely, dated London, 1660, this is Colonel John Page (1628-1692), of Williamsburg, née Middle Plantation, who was the first of the Page family in Virginia. Page was a merchant, member of the Virginia House of Burgesses and the Council of the Virginia Colony. As a wealthy landowner, Page donated land and funds for the first brick Bruton Parish Church. He was also instrumental in obtaining the site of the new College of William and Mary, founded in 1693, a year after his death. *New York Public Library*

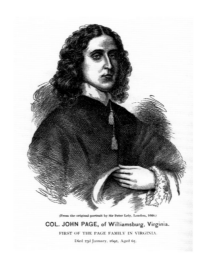

(From the original portrait by Sir Peter Lely, London, 1660.)
COL. JOHN PAGE, of Williamsburg, Virginia.
FIRST OF THE PAGE FAMILY IN VIRGINIA.
Died 23d January, 1692, Aged 65.

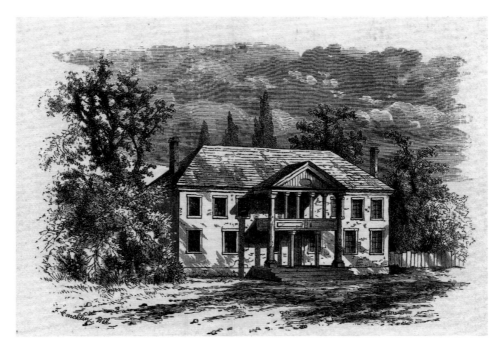

The second building to serve as the Virginia capitol after fire destroyed the first in 1747 was built of imported brick shortly thereafter. Builders reoriented this second capitol building to face west down Duke of Gloucester Street, where it stood until April 1832, when it, too, was consumed by fire. In this building, shown in an engraving that is believed to date to 1870, great deliberations took place that preceded the nation's war for independence, and therein were heard the voices of those Virginia statesmen whose memory have since been immortalized. *New York Public Library*

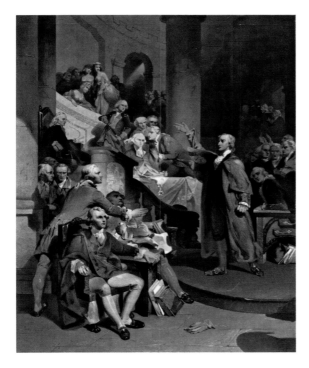

Artist Peter Frederick Rothermel's (1812-1895) engraving depicts Patrick Henry (1736-1799) delivering a speech before the Virginia House of Burgesses at Williamsburg on May 30, 1765. In his now-famous oration, Henry railed against the Stamp Act, declaring, "If this be treason, make the most of it." *Library of Congress*

Published by Robert Sayer and John Bennett, of London, on February 16, 1775, "The alternative of Williams-burg" print shows a "Virginian loyalist" being forced to sign a document, possibly issued by the Williamsburg Convention, by a club-wielding mob of "liberty men." On the left, a man is being led toward gallows (background, right) from which hangs a sack of feathers and a barrel of tar. The art has been attributed to Philip Dawe, a student of William Hogarth. *Library of Congress*

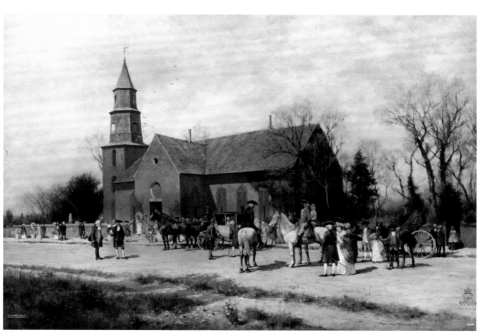

Taken from an Alfred Wordsworth Thompson painting and with Bruton Parish Church as backdrop, this was Williamsburg at the time of John Murray, Fourth Lord of Dunmore (1730- 1809) and Virginia colonial governor (1771-1775). *Library of Congress*

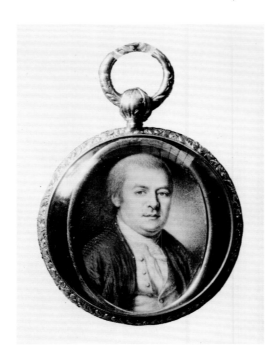

Peyton Randolph (1721-1775) was the subject of this Charles Willson Peale (1741-1827) portrait miniature that dates to the period just prior to the Revolutionary War. Randolph, a cousin of Thomas Jefferson, was attorney general of the Virginia colony and chaired the first and second Continental Congress, leading the Virginia delegation to the second congress at Philadelphia in May 1775. While the commander of the British forces in America issued blank warrants for his capture and hanging, he returned to Williamsburg under patriot escort. He was reelected speaker of the Third Virginia Convention that July, just months before his death from a stroke on October 22. Though first buried at Philadelphia's Christ Church, Edmund Randolph returned his remains to Williamsburg, where he was interred in the Randolph family crypt at the College of William and Mary on November 26, 1776. *National Archives*

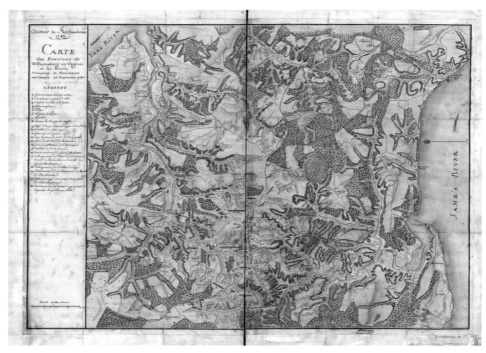

This Jean-Nicolas Desandrouins map of Williamsburg for French marshal Jean-Baptiste Donatien de Vimeur, Comte de Rochambeau (1725-1807) was wrought during the Revolutionary War ahead of the Battle of Yorktown and is dated September 1781. During the war, Rochambeau held the rank of lieutenant general and was dispatched with some 7,000 French troops to join the Continental Army, commanded by General George Washington. Desandrouins (1729-1792) was a French army officer and military engineer. *Library of Congress*

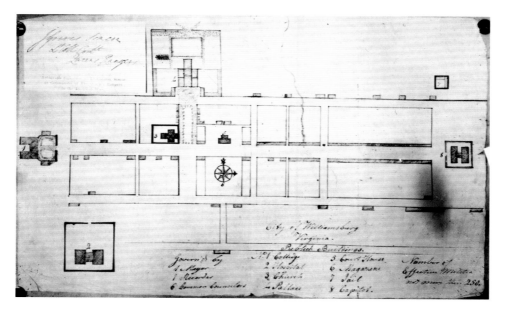

Lieutenant Colonel John Groves Simcoe (1752-1806), a British army officer, drew this map of Williamsburg in 1781 when his unit, the Queen's Rangers, was involved in a skirmish near the Virginia capital and participated in the siege of Yorktown. *Cornell University Library*

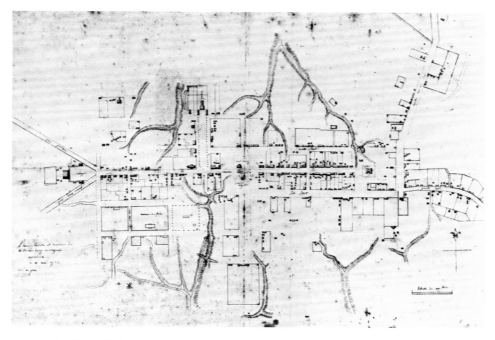

Drawn in 1782 for billeting French soldiers after Lord Charles Cornwallis' surrender at Yorktown, the so-called "Frenchman's Map" documented every building in Williamsburg up to that year. The map was located at the College of William and Mary library in 1927, just as Reverend Dr. William Archer Rutherfoord Goodwin and John D. Rockefeller Jr. launched the restoration of the city that was, without question, the cradle of the nation's liberty. This map, in its meticulous detail, became the bible of Colonial Williamsburg's restoration. *Library of Congress*

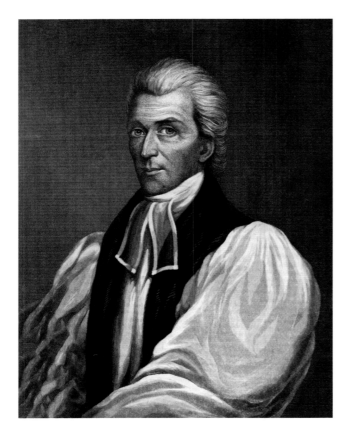

This engraved portrait of the Right Reverend Dr. James Madison (1749-1812), first bishop of Virginia and the eighth president of College of William and Mary, is attributed to Henry Howe (1816-1893). Madison was college president from 1776 to 1812. In 1781, in the last weeks of the Revolutionary War, General Cornwallis and British forces evicted Madison (cousin of the future president of the United States of the same name) and his family from the President's House to set up headquarters there. Fire destroyed the house's interior within weeks of Cornwallis' departure and while it was being used as a hospital for French officers wounded at the Battle of Yorktown. The house was rebuilt in 1786 with funds provided by the French government. *New York Public Library*

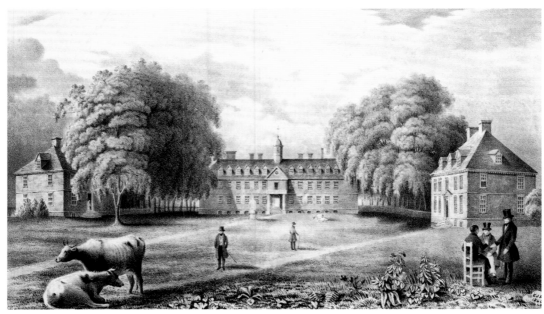

When Thomas Charles Millington wrought this lithograph of the College of William and Mary in 1840, he captured one of the nation's great universities in its salad days. Pictured (left to right) Brafferton Hall (left), the Wren Building (center), and the president's residence (right). *New York Public Library*

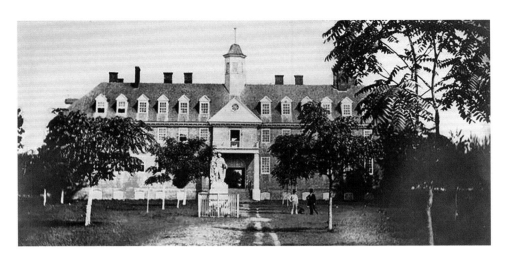

In 1797 the president and professors of the College of William and Mary purchased the 1773 Richard Hayward statue of Norbonne Berkeley, Fourth Baron Botetourt (1718-1770) and governor of the Virginia colony from 1768 to 1770, from the commonwealth and removed it to the college in 1801, partially repaired from vandalism, and placed in front of the Sir Christopher Wren Building [known just then as the "the College" and later as the "Main Building"] in the college yard, where, as a student of the day commented, "it cut a very handsome figure indeed." There it remained for 157 years except for a brief period during the Civil War when it was placed for safekeeping on the grounds of Eastern State Hospital. The practice of freshmen tipping their hats before the statue began sometime after 1900, and when the college became co-ed in 1918 it was customary for entering girls to curtsy to Lord Botetourt. This is the earliest known picture of the Wren Building, derived from a daguerreotype taken in or about 1856. The statue was again removed in 1958 and placed in storage as a protection against vandalism and weathering. Later, it found a permanent home on display in the Botetourt Gallery of the Earl Gregg Swem Library, which held its official opening dedication in 1966. The original sculpture of Lord Botetourt is one of the earliest examples of public statuary in North America and the only one erected by colonists to commemorate a royal governor. *New York Public Library*

A replica of the Lord Botetourt statue (shown in this Pascal Auricht[1] photograph taken on September 30, 2006) was commissioned as part of the College of William and Mary's tercentenary celebration. Due to the deteriorated condition of the original statue, it could not serve as a mold for the new version. Given this circumstance, Washington, D.C. sculptor Gordon Kray, William and Mary class of 1973, created a new statue cast in bronze, working closely with the original sculpture and available portraits of the governor. Lord Botetourt returned to his position in front of the Wren Building on October 23, 1993. Members of the College of William and Mary community greatly missed the statue while it was absent from campus. College rector James Brinkley remarked just then that "the crown has been missing one of its gems and it is back."

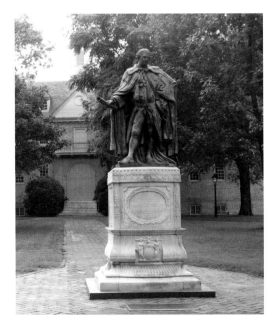

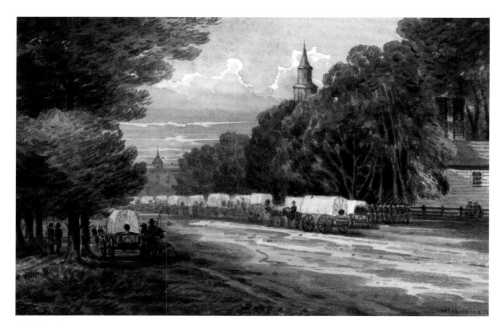

This Civil War watercolor scene of Duke of Gloucester Street depicts soldiers and a wagon train moving toward the College of William and Mary in 1862. *Library of Congress*

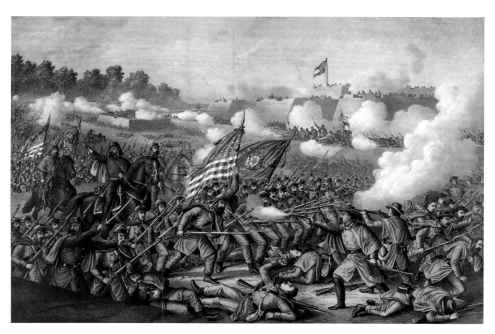

Currier and Ives published this lithograph of Union brigadier general Winfield Scott Hancock's charge at the Battle of Williamsburg, which took place on May 5, 1862. Hancock (1824-1886), a career United States Army officer and the Democratic nominee for president of the United States in 1880, was under the command of Major General George B. McClellan (1826-1885). Confederate troops were under the command of General Joseph E. Johnston, who fought a sharp defensive fight at Williamsburg and turned back an attempt at an amphibious turning movement at Eltham's Landing two days after the engagement depicted here. *Library of Congress*

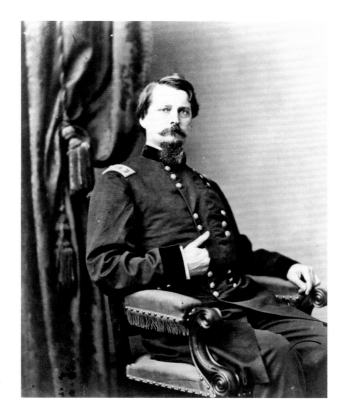

Winfield Scott Hancock, known to his United States Army colleagues as "Hancock the Superb," was notable, in particular, for his personal leadership and heroism at the Battle of Gettysburg in 1863. Hancock was photographed by Campbell Photo Service in 1862; at that time, he was a major general. *Library of Congress*

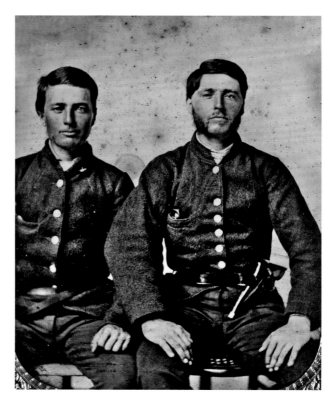

Confederate privates (and brothers) Stephen C. and Moses M. Boynton of Company C, Beaufort District Troop, Hampton Legion, South Carolina Cavalry Battalion, were the subject of this sixth-plate ambrotype, hand colored and in a decorative case. Stephen Boynton (left) was killed in the Battle of Williamsburg on May 4, 1862; he is buried in Williamsburg's Cedar Grove Cemetery. *Library of Congress*

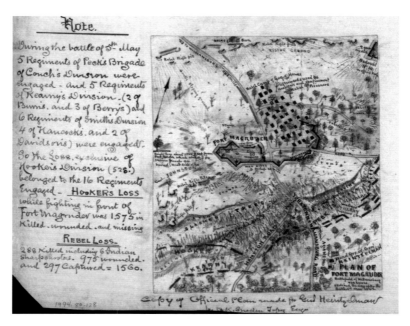

Attributed to Robert Knox Sneden (1832-1918), an American landscape painter and map-maker for the Union Army during the Civil War, this plan of Fort Magruder was sketched the day after the Battle of Williamsburg on May 6, 1862, and shows the area surrounding the Confederate fortification just south of Williamsburg. Details include the network of ravines and slashed trees extending the width of the Peninsula used by the Confederate States Army as part of its defenses. Color coding indicates the location of Union and Confederate forces. *Library of Congress, Geography and Map Division*

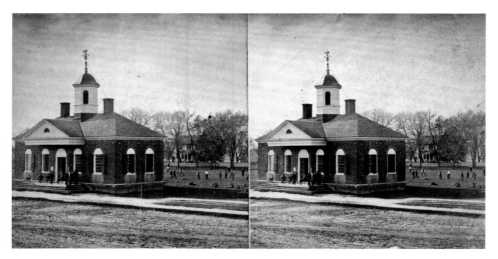

The courthouse shown here was the third to serve the Virginia colony—and, later, new commonwealth—at Williamsburg. The building was erected just before the Revolutionary War in the middle of Market Square and is shown here in an 1870 David H. Anderson (1827-1905) stereoscopic image, part of a series documenting views of Richmond and vicinity, and mountain scenery of Virginia and West Virginia. Anderson worked out of Richmond, Virginia, from 1865 to 1879, and operated a lucrative portrait business in that city. The courthouse continued to be used until 1931, when the city of Williamsburg and surrounding James City County conveyed the building and accompanying green to Colonial Williamsburg. *New York Public Library*

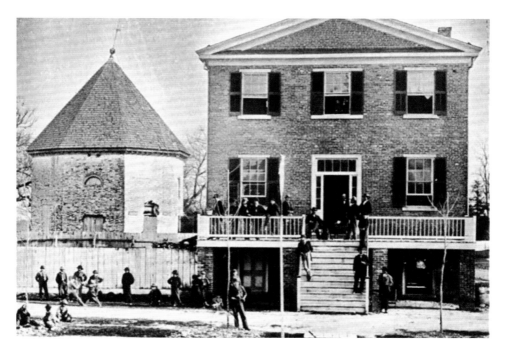

Taken in or about 1875, this is the powder magazine and the Red Circle Club. The photograph, dated by the absence of a two-story porch that was later added to the Red Circle Club, served as the district court building during the Civil War, the Chesapeake and Ohio (C & O) rail station for a short period in 1881, the Hotel Williamsburg for many years, and before it was razed, Dr. Baxter Bell's hospital from 1925 to 1930. The picture was first published in and is attributed to Alois Lawrence Kocher and Howard Dearstyne's *Shadows in Silver: A Record of Virginia 1850-1900*, in 1954.

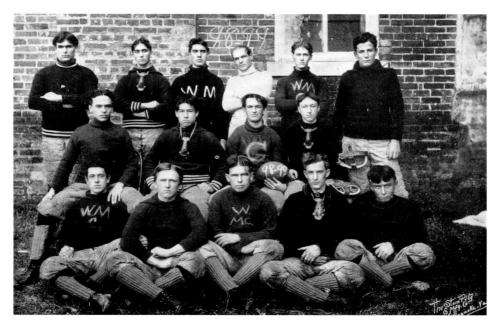

Members of the College of William and Mary football team were photographed for the 1899 *Colonial Echo* yearbook. *College of William and Mary Earl Gregg Swem Library*

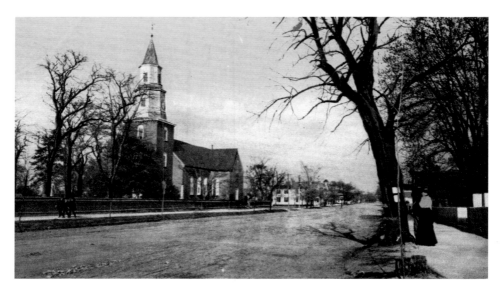

The Detroit Publishing Company published this tinted postcard of Duke of Gloucester Street in 1902. The cruciform-shaped Bruton Parish Church is on the left. Bruton Parish was the court church of colonial Virginia. Plans were furnished by royal governor Alexander Spotswood (1676-1740) and part of the cost was paid by the colonial government. The present church was built between 1710 and 1715 on the site of the earlier church, erected in 1674. *Amy Waters Yarsinske*

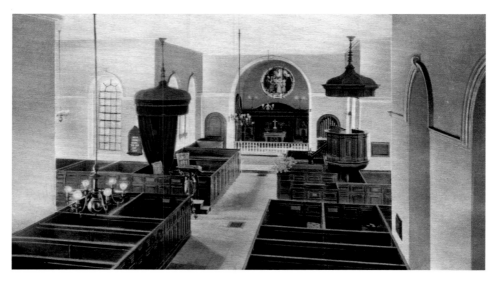

The interior of Bruton Parish Church (shown on this hand-colored postcard) was greatly altered through the eighteenth and nineteenth centuries, followed by a 1905 to 1907 restoration that draped an already compromised interior in what was, just then, a thinly-veiled effort to restore colonial aesthetic and, in fact, resulted in many inappropriate architectural additions to the building. The effort had been initiated by parish rector Reverend William T. Roberts but finished under Reverend Dr. William Archer Rutherfoord Goodwin, who returned as rector from 1926 to 1938, and was instrumental in convincing John D. Rockefeller Jr. to restore Williamsburg. Bruton Parish was part of that effort and between 1939 and 1940, a complete restoration was completed. Colonial governors sat beneath the canopy on the left. Also visible on the left (to the right of the canopy) is the 1907 lectern, a gift of Theodore Roosevelt (1858-1919), the twenty-sixth president of the United States (1901-1909). *Amy Waters Yarsinske*

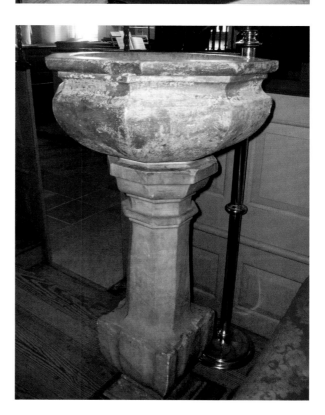

President Theodore Roosevelt presented the bronze lectern (shown in this Michael Kotrady photograph taken on January 17, 2012) to Bruton Parish Church to commemorate the sesquicentennial anniversary of the first permanent English settlement and the establishment of the Anglican church at Jamestown, Virginia. Near the lectern are the gravestones of royal governor Francis Fauquier and Revolutionary War patriot Edmund Pendleton. *Michael Kotrady*[2]

The Bruton Parish Church's baptismal font is the centerpiece of the governor's pew, intended as a solemn reminder of the importance of baptism in the church. The font came to the church in or about 1758 from the church at Jamestown by way of its successor—the Church on the Main—located roughly two miles west of Jamestown on the mainland. The font was photographed also by Michael Kotrady on January 17, 2012. *Michael Kotrady*[3]

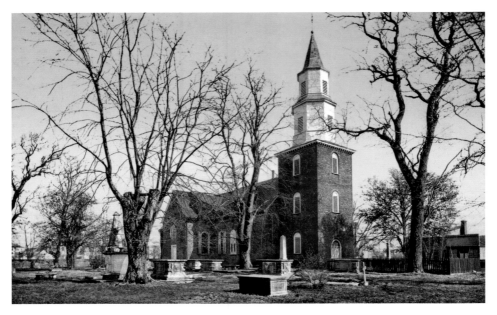

This photochrom of Bruton Parish Church was produced by the Detroit Publishing Company in 1902. The green and portion of cemetery shown here are part of the boundary of the first brick church on the site that dated to 1683. According to the church, Bruton Parish probably has the largest colonial burial site still existing in Virginia. Early tombstones and memorials are found in the forms of chest and table tombs, obelisks, sculptural designs, headstones, and ledger stones—some of the finest examples of Baroque-style funerary art. Of the hundreds of burials in the church grounds, only 148 have permanent markers, and these are made of limestone, marble, sandstone, slate or granite. *Library of Congress*

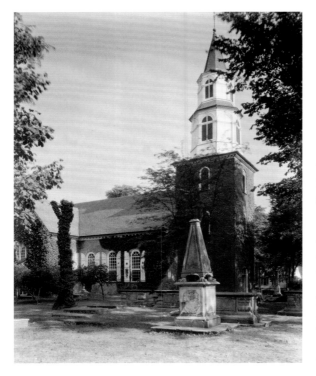

Frances Benjamin Johnston (1864-1952) took this picture of Bruton Parish Church, to include the same green and portion of cemetery in the 1902 Detroit Publishing Company photochrom. The picture was taken in 1930. Prominent in this photograph is the monument erected by Elizabeth Page Bray (1702-1734) in honor of her late husband, David Bray (1699-1731), and as a tribute to their love. The unusual monument is an obelisk resting on four eagle's feet on top of the base. *Library of Congress*

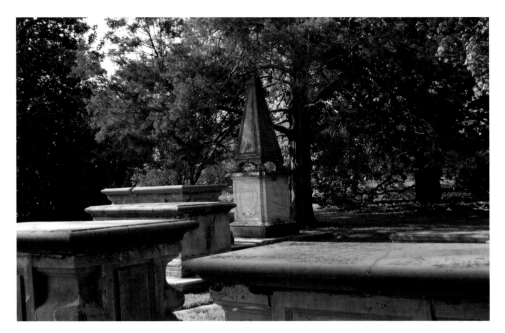

Harvey Barrison, of Massapequa, New York, took this picture of the David and Elizabeth Page Bray obelisk and surrounding tombs in the Bruton Parish churchyard on April 26, 2008. The Bray family owned land throughout Charles and James City Counties. Had he not died in the prime of his life, David Bray's marriage to Elizabeth Page would have continued the Bray family wealth and influence in the colony; Elizabeth was the eldest daughter of Colonel John Page. *Harvey Barrison*[4]

Colonel Daniel Parke Custis (1711–1757), son of Colonel John and Frances Parke Custis, and husband of Martha Dandridge (1731-1802), married on May 10, 1750, in New Kent County, Virginia, is buried in the Bruton Parish cemetery. This engraving from Benson J. Lossing and William Barritt dates to the nineteenth century. Martha Dandridge Custis married again—famously—to George Washington on January 6, 1759. *New York Public Library*

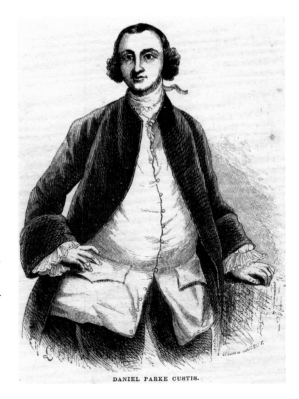

DANIEL PARKE CUSTIS.

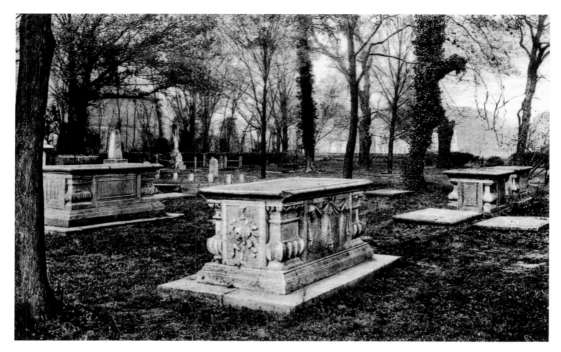

In the foreground of this 1938 real picture postcard is the grave of royal governor Edward Nott (1657-1706), his tomb paid for by the Virginia General Assembly. To the left of Nott's tomb are the graves of the Bray family. *Amy Waters Yarsinske*

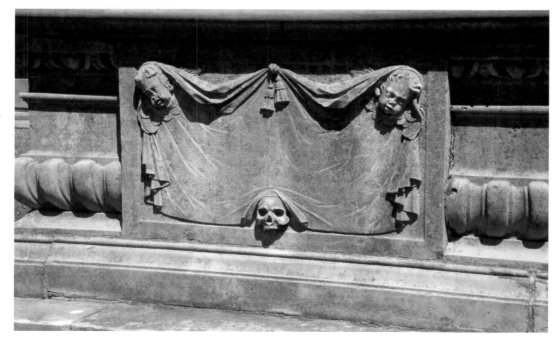

Royal governor Edward Nott's final resting place bears this carving on the south face of the tomb representing the curtain of life being lowered. Nott was in office long enough to witness the beginning of construction of the Governor's Palace. Sarah Stierch took the picture shown here on April 27, 2009. *Sarah Stierch*[5]

This is the east side detail of royal governor Edward Nott's tomb in the Bruton Parish cemetery, photographed on January 17, 2012, by Michael Kotrady. *Michael Kotrady*[6]

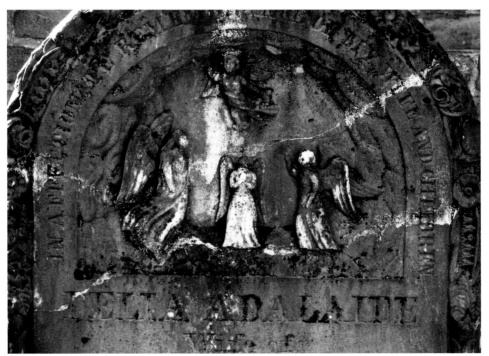

Detail of the headstone of Delia Adelaide Churchill Higgins Bucktrout (1817-1857), formerly of New Kent County, is shown in this picture taken January 17, 2012, also by Michael Kotrady. She was the first wife of Richard Manning Bucktrout, whose family is tied to one of the oldest mortuary companies in the United States, established in 1759. Like most early funeral service establishments, the Bucktrouts were cabinet and furniture makers, and it is known that they also made and repaired spinets and harpsichords. Richard Bucktrout (1805-1867) advertised as an undertaker, fashioning simple pine coffins for the poor and elaborately carved mahogany models for his wealthy customers. Eventually, metal coffins made their appearance at his South Back Street shop. *Michael Kotrady*[7]

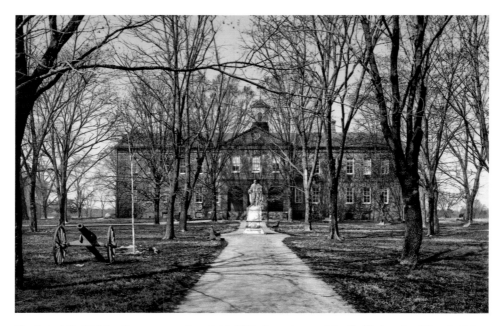

The Detroit Publishing Company marketed this 1902 photochrom of the Sir Christopher Wren Building ("the Wren Building") at the College of William and Mary. The Wren Building is the oldest college building in the United States and the oldest of the restored public buildings in Williamsburg but it was not named for the famous British architect until 1931. According to the college's history of the building, it was constructed between 1695 and 1699, before the city was founded, when the capital of the Virginia colony was still located at Jamestown, and the land that would eventually become Williamsburg was known only as "Middle Plantation." *Library of Congress*

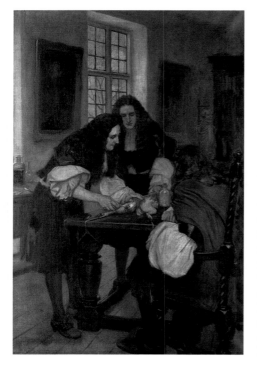

Sir Christopher Wren (1632-1723) was a seventeenth-century British designer, astronomer, geometer, and one of the greatest English architects of his time. An eighteenth-century author attributed the design of the College of William and Mary's first building to him. Wren designed 53 London churches, including Saint Paul's Cathedral, as well as many secular buildings of note. He was a founder of the Royal Society (to which he was president from 1680 to 1682), and his scientific work was highly regarded by Sir Isaac Newton and Blaise Pascal. This oil painting by Ernest Board (1877-1934) depicts Wren making his first demonstration of a method of introducing drugs into a vein before Dr. Thomas Willis in 1667. *Wellcome Trust*

Bruton Parish Church was photographed by Harry C. Mann in 1907. *Amy Waters Yarsinske*

The Model School—also called the Matthew Whaley Grammar School—was built in 1870 on the site of the Governor's Palace, just behind Williamsburg High School. The school's full name was the Matthew Whaley Model and Practice School of the College of William and Mary but most residents called it "Matty Whaley" or "The Matty School." The school served as a vehicle for instructing future teachers. William and Mary education majors did their student observation there, subsequently returning to complete their practicum. In July 1873, the school was leased to the town as a free school, an association that ended in July 1894 and the college board reorganized it as the model school. The Virginia Electric and Power Company (VEPCO) plant is in the background. The picture dates to 1907. *College of William and Mary Earl Gregg Swem Library*

The site of the 1705-1747 capitol building at the east end of Duke of Gloucester Street—also called Main Street—was the subject of this 1909 stereo card. The first building, erected between 1701 and 1705, was destroyed by fire in 1747. A second building was constructed on the site soon after but was abandoned in 1779 when the Virginia General Assembly moved the state capital to Richmond. The second building later served as a school, a military hospital, and a court; it, too, was destroyed by fire in 1832. Of note, in 1839 a female academy was built on the capitol site and in 1881 the last traces of this building were removed. The site was presented by the Old Dominion Land Company to the Association for the Preservation of Virginia Antiquities (APVA) in 1897, which placed the marker shown here on the east side of Blair and Duke of Gloucester Streets. The association protected and preserved the old foundations of the capitol until July 16, 1928, when it presented the land to the Colonial Williamsburg Foundation ("Colonial Williamsburg"). From 1928 the old foundations were excavated and archaeological investigation undertaken. Following an extensive research campaign, the capitol was rebuilt upon its original foundations. *Library of Congress*

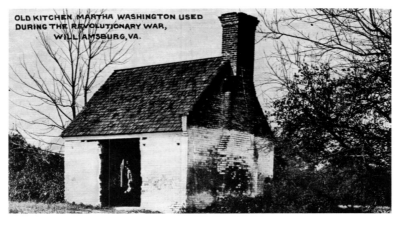

From Colonial Williamsburg documentation, tradition tells that this small brick building in the exercise yard—also described as the garden—of the Eastern State Hospital was the eighteenth-century kitchen of the home of Daniel Parke Custis, who had inherited it from his father, Colonel John Custis, in 1749. Martha Dandridge Custis, the widow of Daniel Parke Custis, later married General George Washington, who adopted her son, John Parke Custis. The kitchen, shown on this 1915 postcard, was built as part of the Custis Square property bounded by Francis, Nassau, Ireland and King Streets. For generations, it was described as surrounded on all sides by holly and cedar trees, even after the square was absorbed by the hospital grounds. *Amy Waters Yarsinske*

The John Blair House, located on the north side of Duke of Gloucester Street about the center of the block bounded by Henry, Nassau, Prince George and Duke of Gloucester Streets, is shown on this 1910 period postcard. This is one of the oldest houses in Williamsburg, part of the residence dating to the early eighteenth century, when John Blair Jr.'s, one of the original justices of the United States Supreme Court's, uncle, Reverend James Blair (1656-1743), was founder and first president of the College of William and Mary. According to tradition, it is believed that the stone steps at both doors originated with the Palace Street theater and were added to the home when the residence was lengthened to twenty-eight feet to the west sometime during the second quarter of the eighteenth century.[8] With other College of William and Mary professors, Reverend Dr. William Archer Rutherford Goodwin saved the John Blair House from demolition to make way for a gasoline station—and turned it into a faculty club. *Amy Waters Yarsinske*

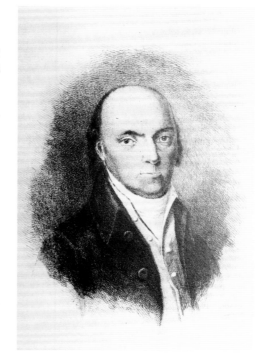

John Blair Jr., one of the original six justices of the United States Supreme Court and resident of Williamsburg, was born in 1732 and educated at the College of William and Mary, from which he graduated with honors in 1754, before he took a seat in the Virginia House of Burgesses, representing the college. He went on to draft Virginia's constitution in 1776 and served on the committee that approved Virginia's Declaration of Rights. The Virginia legislature appointed him to the General Court in 1778 and from that post he advanced quickly up the judicial ladder. New president of the United States George Washington appointed Blair to the newly established Supreme Court in September 1789. Blair's deteriorating health forced his resignation on October 25, 1795, and he died at Williamsburg on August 31, 1800. This Harris and Ewing photograph of an early engraving of Blair was published in 1936. *Library of Congress*

Above: According to Williamsburg Masonic Lodge No. 6 A.F. and A.M. history, while there is some evidence to suggest that a lodge of freemasons was likely active in Williamsburg as early as the 1730s, the Grand Lodge of Virginia recognizes the Norfolk lodge as being the first one in Virginia. Most certainly, a lodge was active and meeting in Williamsburg's Crown Tavern, located on the south side of Duke of Gloucester Street across from the printing office and post office, in 1762. Meetings continued at this location until the lodge relocated to the Market Square Tavern, owned by Gabriel Maupin, in 1773 but this, too, was a temporary arrangement. Within a year, in 1774, the lodge was able to complete the two-story, wood-frame lodge hall (shown on this early twentieth century postcard) on a nearby lot. This lot, owned by William Lightfoot, was located near the corner of Francis and Queen Streets. On June 23, 1778, representatives of all the Virginia masonic lodges duly elected John Blair Jr., past master of Williamsburg Lodge No. 6, as the first grand master of masons in Virginia. Blair was formally installed as grand master in the Williamsburg lodge hall at a meeting of the assembled lodges held on October 13, 1778. The Grand Lodge of Virginia was also thusly created that day, which was the first grand lodge constituted in North America. By late 1891, the 117-year-old lodge shown here was presumed outgrown and in sore disrepair and the Williamsburg masons began meeting at Mahone's Store, located on the southeast corner of Duke of Gloucester and Botetourt Streets (where Tarpley's Store is located today). There would be more changes of venue. At the turn of the twentieth century the Williamsburg lodge returned to the old building they had long ago abandoned, hoping to restore it. But decades of neglect could not be erased. The 1774 lodge building was razed in 1910. *Amy Waters Yarsinske*

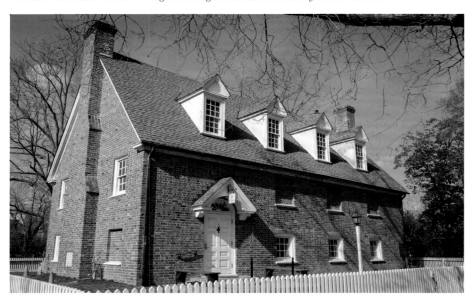

Opposite below: Bricks from the foundation of the 1774 Williamsburg masonic lodge were saved and subsequently incorporated into the fireplace in the downstairs social hall of the current temple building, which was built on the site of the old one, in 1931 (shown in this April 12, 2015 photograph). Vestiges of the original building remain there, including a bronze plaque that describes the lodge's historical significance. The current temple was built with the cooperation of the Colonial Williamsburg Foundation, largely the initiative of Reverend Dr. William Archer Rutherfoord Goodwin, who was an affiliate member and chaplain of Williamsburg Lodge No. 6 from 1904 to 1908. *Smash the Iron Cage*[9]

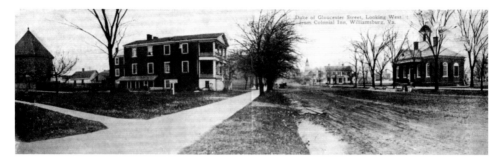

This is Duke of Gloucester Street looking west from the Colonial Inn in Market Square, published in or about 1914 on a double-width postcard. Buildings (left to right) are the powder magazine (also called the powder horn); outbuildings; Hotel Williamsburg; Bruton Parish Church in the distance; the Roscow Cole House, facing the palace green (center), which has anchored the east end of Market Square since 1812; the George Wythe House (in the distance between the Roscow Cole House and the courthouse); the courthouse, and the St. George Tucker House, barely visible just to the right of the courthouse. *Amy Waters Yarsinske*

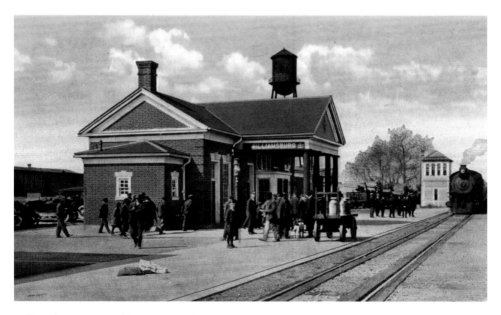

Williamsburg's original late nineteenth-century train station was replaced in 1907 with a newer brick structure in conjunction with celebration of Jamestown's tercentennial anniversary. But then, in 1935, that station, formerly situated behind the site of the Governor's Palace just west of where North England Street empties onto Lafayette Street, was replaced with a newer one at the present location on North Boundary Street with funding from John D. Rockefeller Jr.'s restoration effort. The 1907 railway depot is shown on this postcard that dates to May 1916. The tower to the right (next to the track) belonged to the Virginia Electric and Power Company (VEPCO), formerly Williamsburg Power Company. *Amy Waters Yarsinske*

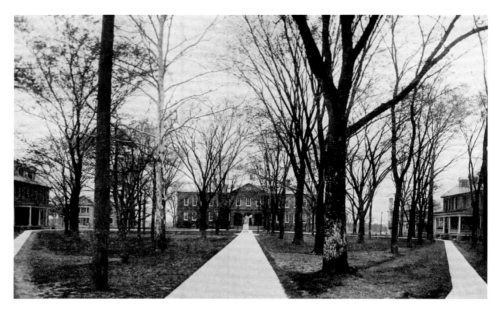

The College of William and Mary's college yard was photographed in 1915 by an unknown photographer and again on April 11, 2015. The university's three colonial period buildings (left to right)— Brafferton Hall, the Wren Building (the main building) and the President's House—anchor the historic campus. The construction of the main building began in 1695. Design of the college's main building is attributed to Sir Christopher Wren, for whom it was named in 1931. The building was gutted by fire three times—in 1705, 1859 and 1862—and each time the interior of the building was rebuilt. From 1928 to 1931, the Wren Building was restored to its colonial appearance as part of the John D. Rockefeller Jr. restoration of Williamsburg. The College of William and Mary calls the Wren Building "the soul of the college." *College of William and Mary Earl Gregg Swem Library* (before), *Smash the Iron Cage* (after)[10]

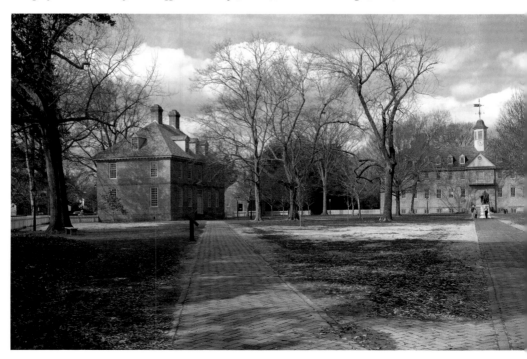

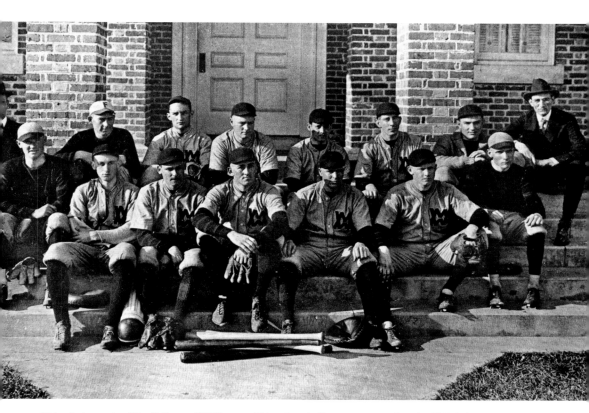

This photograph of the College of William and Mary baseball team appeared in the 1916 *Colonial Echo*, the college's yearbook. *College of William and Mary Earl Gregg Swem Library*

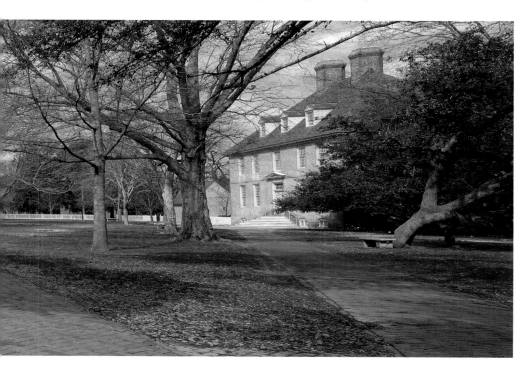

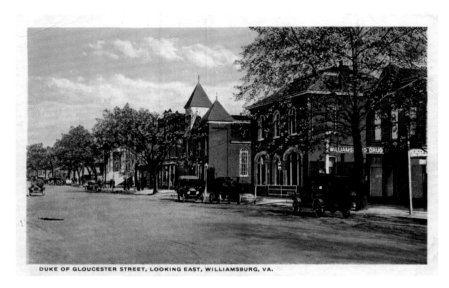

DUKE OF GLOUCESTER STREET, LOOKING EAST, WILLIAMSBURG, VA.

This white border period (1915-1930) postcard shows Duke of Gloucester Street looking east before 1920. Dating the card is the 1842 Duke of Gloucester Methodist Church (center, two towers) that stood on the south side of the street in Market Square. The church was a hospital for Confederate wounded in 1862. When the church moved to College Corner, the building became the town's post office until it was razed in the 1930s as part of the Colonial Williamsburg restoration effort. *Amy Waters Yarsinske*

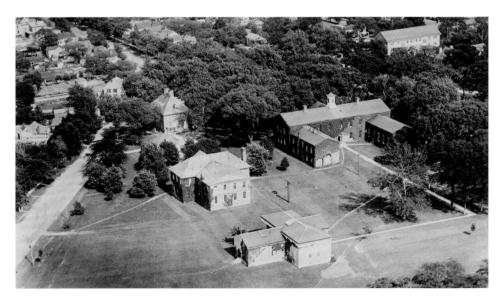

This Bain News Service photograph was taken as part of an aerial series of photographs of the College of William and Mary in 1922. The perspective is from the west side of town. The Wren Building anchors the terminus of Duke of Gloucester Street, visible beyond the cluster of mature trees top left in the photograph. The President's House, in this picture surrounded by trees and northeast—upper left—from the Wren Building and facing Richmond Road, was built in 1732 and has been the home of the presidents of the since that time. It is the oldest college president's house in the United States. *Continued on page 33.*

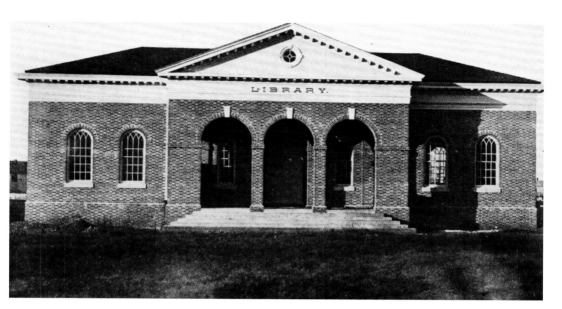

The College of William and Mary's library was still under construction when an unknown photographer took this picture in 1908. Tucker Hall, as it later came to be known, was named for St. George Tucker in 1980, and had been renovated and expanded several times before it ceased as a library facility after the completion of the Earl Gregg Swem Library in 1966 (shown below as it appeared on April 11, 2015). *College of William and Mary Earl Gregg Swem Library* (before), *Smash the Iron Cage* (after)[11]

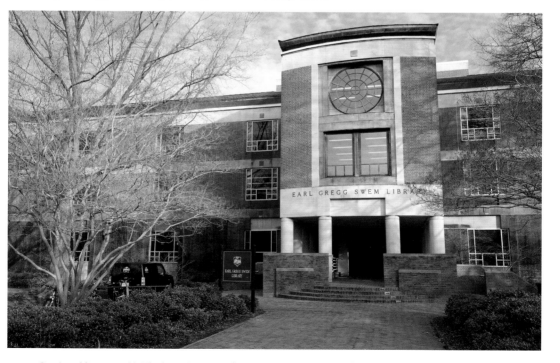

Continued from page 32: The large building (center of the photograph) located northwest of the Wren Building is Science Hall, built between 1904 and 1905, dedicated on April 27, 1906, and demolished in the fall of 1932. The earliest iteration of Tucker Hall, the college's first dedicated library building completed and opened in 1909 and known only just then as "the library," is shown at the bottom of the photograph. *Library of Congress*

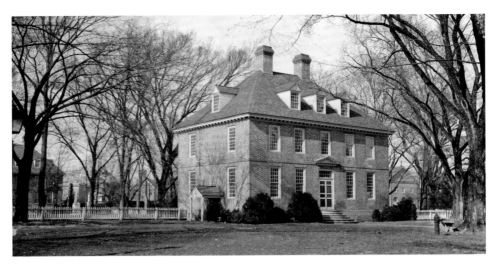

An undated early twentieth-century photograph of Brafferton Hall and the college yard at the College of William and Mary was taken prior to the 1932 restoration by the Colonial Williamsburg Foundation. Built in 1723 as an Indian school, funds for its erection and operation came from a bequest by Robert Boyle, English inventor of the air pump. Henry Cary Jr., of Ampthill, a building contractor, was highly likely the building designer based on his similar known work on the President's House and the chapel in the Wren Building. Brafferton Hall, the second oldest building on the campus, has been in constant use since its construction, functioning as a school, dormitory, and college offices, and it was used as the model for the President's House across the yard. *Library of Congress*

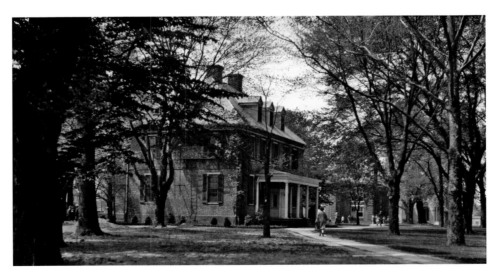

Brafferton Hall, situated on Jamestown Road directly across the college yard from the President's House, ceased operation as an Indian school at the time of the American Revolution, when it lost funding from the Robert Boyle estate. The only one of the College of William and Mary's three colonial buildings to escape destruction by fire, the Brafferton did suffer loss of its interior during the Civil War, when the doors and much of the flooring were removed and used for firewood. According to the college's history of the building, window frames and sashes were reportedly removed and used in quarters for Union officers at Fort Magruder. The exterior brick walls of the Brafferton remain the most substantially original of the three colonial structures on campus. The Brafferton was photographed in 1928 by Charles S. Borjes. *Sargeant Memorial Collection, Norfolk Public Library*

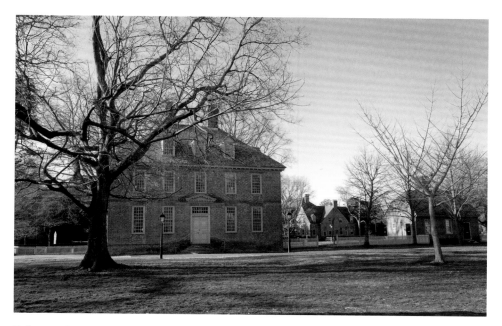

Today, Brafferton Hall, photographed on April 11, 2015, houses the offices of the president and provost of the college. *Smash the Iron Cage*[12]

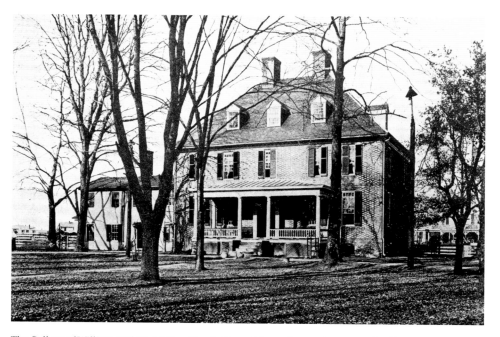

The College of William and Mary's President's House (shown here as it appeared in 1908 and situated on the Richmond Road side of the college yard) remains the oldest official residence for a college president in the United States, serving as the home to all but one of the college's presidents. According to the college's history, only Robert Saunders, president from 1846 to 1848, continued to occupy his house on Palace Green during his tenure. The foundation of the residence was laid on July 31, 1732, and construction was overseen by Henry Cary Jr. The President's House is almost identical to the Brafferton across the college yard, which had been built a decade earlier. *College of William and Mary Earl Gregg Swem Library*

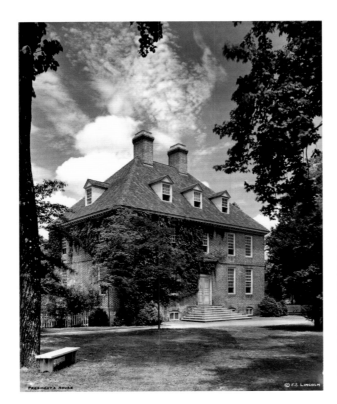

Fay S. Lincoln took this picture of the College of William and Mary's President's House in 1935, four years after the Rockefeller restoration, begun in April 1931 and completed in September of that year. This first restoration removed the exterior additions seen in the 1908 photograph. *Cornell University Library*

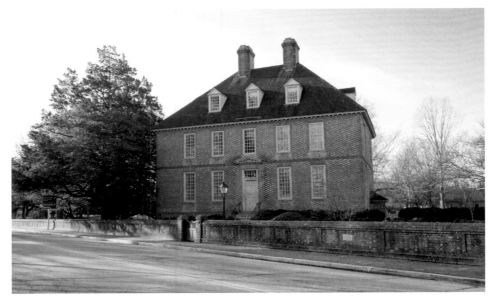

The President's House at the College of William and Mary, shown in this April 11, 2015 photograph from the Richmond Road exposure, was restored in 1931 as part of the Rockefeller restoration of Williamsburg. Further changes to the interior have been made to provide modern upgrades to the home since that time. The public rooms on the first floor are furnished with English and American antiques as well as Colonial American portraits from the collection of the college's Muscarelle Museum of Art. This photograph shows clearly the building's original Flemish bond brickwork. *Smash the Iron Cage*[13]

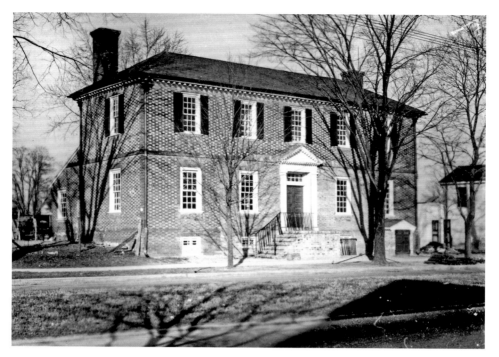

The Georgian-style Ludwell-Paradise House, photographed in 1926, is located on the north side of Duke of Gloucester Street between Queen and Colonial Streets. The house was built about 1755 by Philip Ludwell III, a wealthy planter and politician, and was fully restored to its colonial appearance by Colonial Williamsburg in 1931. This residence once housed the *Virginia Gazette* newspaper and was the first building purchased by Reverend Dr. William Archer Rutherfoord Goodwin and John D. Rockefeller Jr. for restoration. *Sargeant Memorial Collection, Norfolk Public Library*

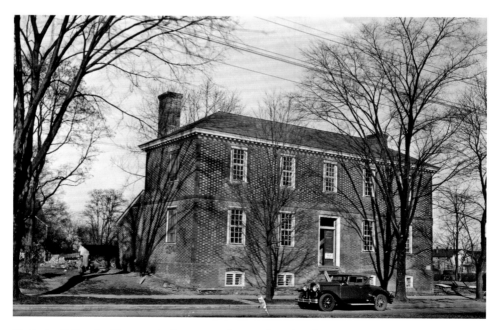

The Ludwell-Paradise House was in the process of restoration when this picture was taken. *Library of Congress*

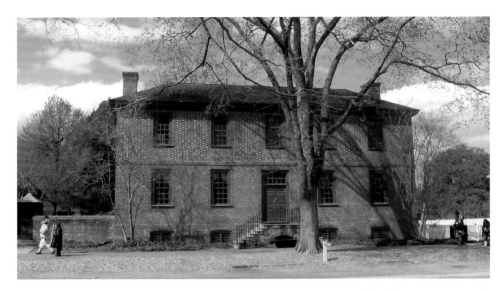

The Ludwell-Paradise House on Duke of Gloucester Street was photographed by Albert Herring on April 7, 2007. The house's first owner, Philip Ludwell III, was a member of the Governor's Council. Ludwell also owned Green Spring plantation in adjoining James City County and eight other farms. His father, Philip Ludwell II, had been a member of the House of Burgesses and one of the city's original trustees in 1699. The house is not a Colonial Williamsburg exhibition site. *Albert Herring*[14]

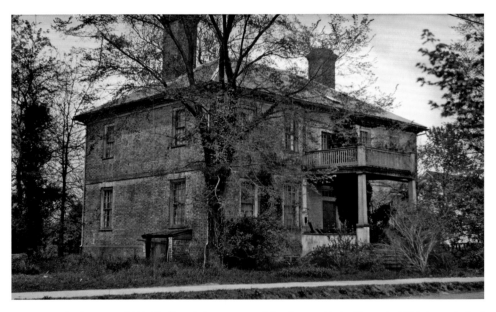

When Charles S. Borjes (1891-1959) took this picture of the George Wythe House in 1924, it was in bad repair. Located on the west side of the Palace Green between Duke of Gloucester and Prince George Streets, the residence was built between 1752 and 1754 by planter Richard Taliaferro for his daughter Elizabeth and her new husband, George Wythe (1726-1806). During the Revolutionary War, the home was used by General George Washington as his headquarters just before the siege of Yorktown. In 1926 architect Charles M. Robinson adapted the house for use as the Bruton Parish Church rectory; Reverend Dr. William Archer Rutherfoord Goodwin established his offices on the second floor. The Colonial Williamsburg Foundation obtained the property in 1938. *Sargeant Memorial Collection, Norfolk Public Library*

In addition to being the first American law professor and a Virginia judge, George Wythe was arguably the most impressive scholar of his day. He served as the first chair of law at the College of William and Mary from 1779 to 1789. Wythe's earliest known apprentice was Thomas Jefferson from 1762 to 1765. Future apprentices included James Madison, who would later become president of the college, and St. George Tucker, Wythe's successor, according to William and Mary's Wolf Law Library. Wythe was a delegate to the Continental Congress, and Virginia's first signer of the Declaration of Independence. Of note, Wythe was also an ardent opponent of slavery. This portrait of Wythe (from the larger painting) hangs in the law school library. *College of William and Mary Wolf Law Library*

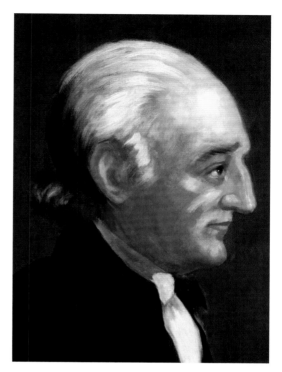

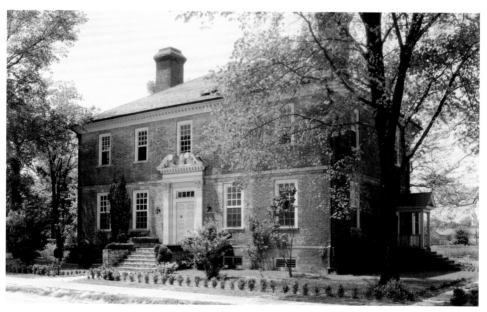

This is the George Wythe residence after the Charles M. Robinson restoration. Frances Benjamin Johnston (1864-1952) took this photograph of the house between 1930 and 1939 as part of the Carnegie Survey of the Architecture of the South. During this project, Johnston created a systematic record of early American buildings and gardens with the intent to help preserve and inspire interest in American architectural history. The Carnegie Corporation became her primary financial supporter and provided six grants to her in the 1930s. Of note, in 1776 the house accommodated Virginia General Assembly delegate Thomas Jefferson and his family. *Library of Congress*

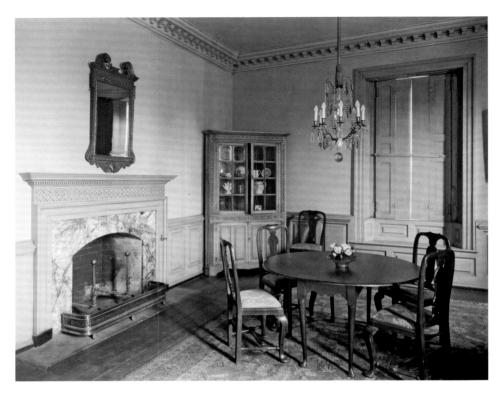

This was the dining room of the George Wythe residence before the Colonial Williamsburg restoration. The room includes a fireplace and bowfat (a china cupboard) on the inside wall. Wainscot lines this room and there is crown molding. The picture was taken by Frances Benjamin Johnston between 1930 and 1939. *Library of Congress*

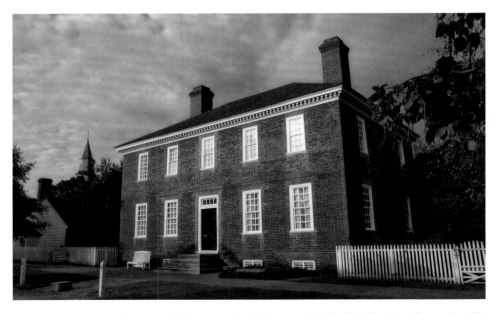

This is the George Wythe House, fully restored and photographed by Rob Shenk on September 22, 2012. *Rob Shenk*[15]

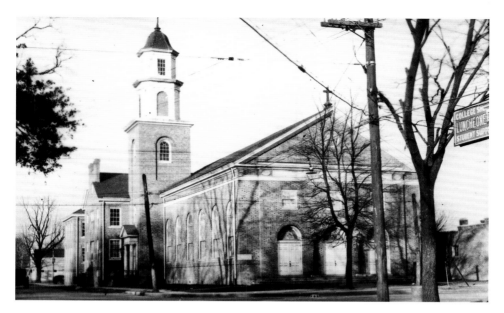

The Williamsburg United Methodist Church on College Corner, a location that also gave it the name "Corner Church," was constructed in 1926, when this picture was taken. The church was constructed on this site to better serve the students at the College of William and Mary. Located at the corner of Duke of Gloucester Street and North Boundary Street in Merchants Square, the church building was purchased by the Colonial Williamsburg Foundation in 1962 and demolished in 1981. The parsonage, also built in 1926, still stands and is retail space on Merchants Square. *Sargeant Memorial Collection, Norfolk Public Library*

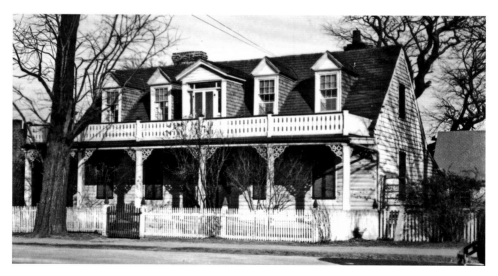

The Brush-Everard House on the northeastern-most corner of Palace Green, and just southeast of the Governor's Palace was built in 1718 by John Brush, a gunsmith, armorer and first keeper of the magazine. Brush died in 1727. Thomas Everard purchased the house in 1755 and lived in it for 25 years. Everard was twice the mayor of Williamsburg, clerk of the York County Court, and later deputy clerk of the colonial general court. In the early twentieth century, the home gained fame as the "House of Audrey," a reference to the heroine of the popular novel by Mary Johnston. The house has been modified many times over and is shown here as it appeared in 1926, before restoration to the period of Everard's 1773 occupancy. *Sargeant Memorial Collection, Norfolk Public Library*

Constructed in 1748/9, the Secretary's Office is the oldest archival structure in the western hemisphere and an original example of eighteenth-century thinking about how to make a building fire safe and reliably dry. Colonial Williamsburg records indicate that the origins of the hip-roofed, one-story brick building are found in the flames that consumed the capitol building on January 30, 1747. From that conflagration were saved many of the records stored next to the General Court in the office of the colony's secretary. The question was how to preserve these and similar documents from further danger and thus the construction of this public records repository, photographed in 1926. *Sargeant Memorial Collection, Norfolk Public Library*

The Secretary's Office was used for records storage until the Virginia capital moved to Richmond in 1780. The building later served as the court of admiralty, the home of Maury Walker, headmaster of the grammar school in the old capitol building, then as a female academy, and finally as the home of the Garrett family. Today, it is the only building still standing that was used by the colonial government for administrative purposes. This picture was taken by Frances Benjamin Johnston between 1930 and 1939. *Library of Congress*

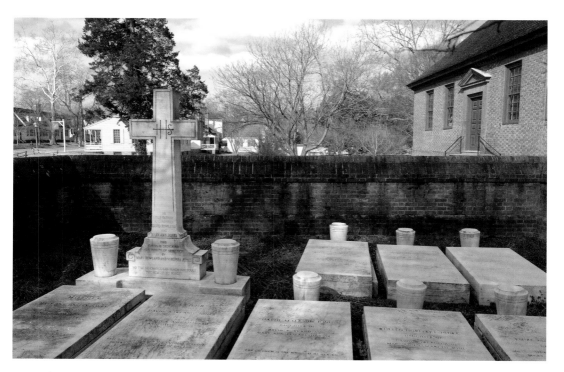

The Jones family cemetery, also known as the Secretary's Office graveyard, is located at the east end of Duke of Gloucester Street, near the capitol building and is shown here as it looked on March 28, 2015. There are nine known interments in this cemetery. *Smash the Iron Cage*[16]

The Secretary's Office was photographed by Harvey Barrison on April 27, 2008. *Harvey Barrison*[17]

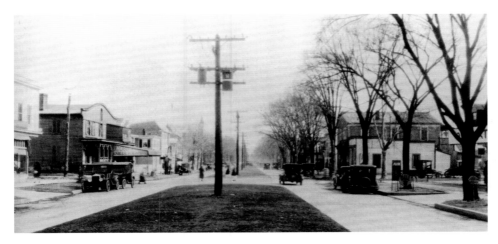

This is Duke of Gloucester Street looking east prior to the start of the John D. Rockefeller restoration. Williamsburg was a bustling, vibrant modern town before reverting to its colonial past. Going back in time affected the lives of many Williamsburg inhabitants.[18] Of note, in 1881, a temporary railroad track ran down the street to move visitors to and from the centennial celebration of the siege of Yorktown, and also to Newport News. This spur of the Chesapeake and Ohio's Peninsula extension was incredibly short-lived. *University of Virginia Library*

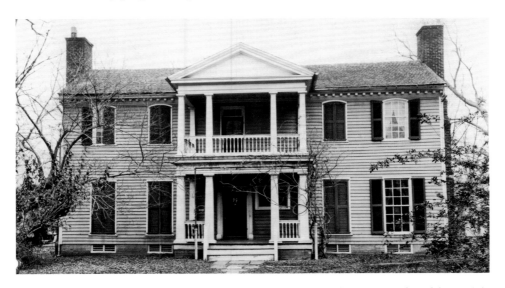

Bassett Hall—an eighteenth-century farmhouse—was built by Philip Johnson, a member of the Virginia House of Burgesses, between 1753 and 1766. The property was named for Martha Washington's nephew, Burwell Bassett Jr. (1764-1841), a member of the Virginia House of Delegates from 1787 to 1789, and the Virginia Senate from 1794 to 1805, who purchased the house in 1800. George Washington was a frequent visitor to the house. Bassett was also the first cousin of President William Henry Harrison (1773-1841). John Tyler (1790-1862) was living at Bassett Hall when he was notified in April 1841 that Harrison had died (the first president to die in office) and he had become the tenth president of the United States. During the Civil War the Union cavalry officer George Armstrong Custer stayed in the house for ten days, in the city to attend the wedding of a United States Military Academy classmate John W. Lea, a Confederate officer who had been wounded at the Battle of Williamsburg. Here, too, the great poet Thomas Moore wrote his "Ode to the Fire-Fly." Bassett Hall was photographed prior to restoration on June 26, 1928. *Amy Waters Yarsinske*

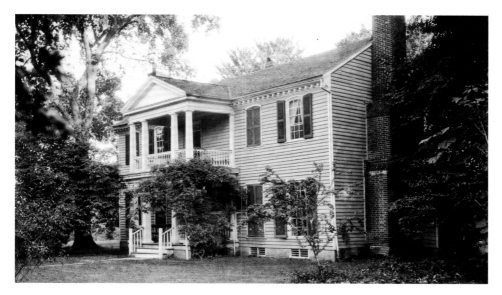

The Reverend Dr. William Arthur Rutherfoord Goodwin encouraged philanthropist and Standard Oil heir John D. Rockefeller Jr. to purchase Bassett Hall for himself. The house and grounds became the Rockefellers' residence during their twice-annual trips to Williamsburg. Abby Aldrich Rockefeller decorated the home with folk art. Bassett Hall remained in the Rockefeller family until 1979, when it was bequeathed to Colonial Williamsburg. This picture of Bassett Hall was taken in December 1929. Of note, even after an extensive renovation, completed in December 2002, the house looks as it did in the 1930s and 1940s, in the early period of the Colonial Williamsburg restoration, when John D. and Abby Aldrich Rockefeller lived there. *Amy Waters Yarsinske*

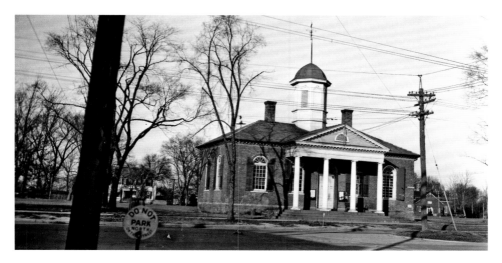

The courthouse, built to serve both Williamsburg and James City County, was built between 1770 and 1772. The building housed a courtroom and rooms for justices and juries. The various dimensions of the building are geometrically related. Columns to support the classical, cantilevered pediment were apparently intended but never installed. The designer is not known, but circumstantial evidence indicates that it was Robert Smith of Philadelphia. The roof and interior of the courthouse were gutted by fire in 1911. The structure was rebuilt immediately within the old walls, with columns under the pediment. In 1932 the building was restored by Colonial Williamsburg, the present owner. This picture was taken in 1929, before that restoration. *Library of Congress*

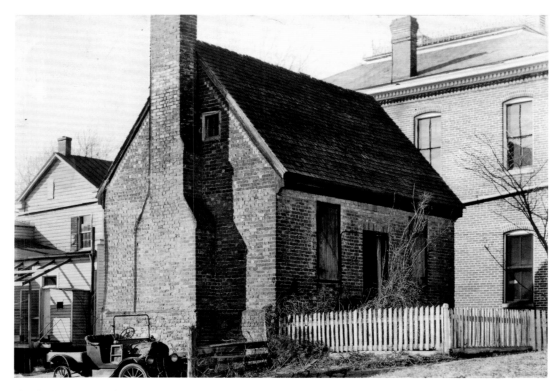

This building, located on Market Square, was known for many years as the "debtors' prison" yet no evidence has thus far come to light to indicate that it was built for this use. The windows throughout were substantially barred, and the larger ones had reinforced shutters. This would suggest that it had at one time been used as a jail, but the architectural evidence reveals that these are late additions, possibly when it served as a city jail. The history of the ownership of the building seems to support the assumption that it was built to serve as a place for the sale of goods or, possibly, for their storage. John Greenhow, the first recorded owner, was a merchant in the town from about 1755 through 1787. He kept a store, at which time he inserted a notice in the *Virginia Gazette* (1766) that gives its location as "near the Church." It is therefore quite possible that he carried on his business in this building. Do not be misled by the term "office" used to describe the building. According to historical reporting on this structure, there were in Williamsburg in colonial times a number of small buildings called "offices" that were used by lawyers, scriveners, men who drew deeds, contracts and other legal papers. When it was photographed on July 22, 1926, the building was still popularly believed to be a debtors' prison. *Amy Waters Yarsinske*

Opposite above: The St. George Tucker House on Nicholson Street, photographed in 1926, belonged to one of Virginia's most prominent lawyers, Revolutionary War militia officers and judges. In 1788 Tucker (1752-1827) purchased three lots, which included the former home of William Levingston, as well as Levingston's theater, purportedly the first in America. After the state capital moved to Richmond and the Governor's Palace was gone, Tucker moved what had been Levingston's 1716 residence facing the Palace Green to the more fashionable Market Square. The house remained in the Tucker family through its Coleman family descendants for more than 150 years. In 1930, the family deeded the house to Colonial Williamsburg with a clause that allowed family members to live there until the last of them passed away. The picture was taken in 1926. *Sargeant Memorial Collection, Norfolk Public Library*

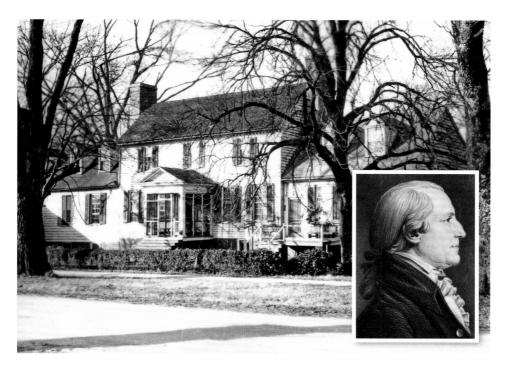

Inset: This engraving of St. George Tucker is the work of Charles Balthazar Julien Févret de Saint-Mémin (1770-1852). The work is believed to date to 1783. *New York Public Library*

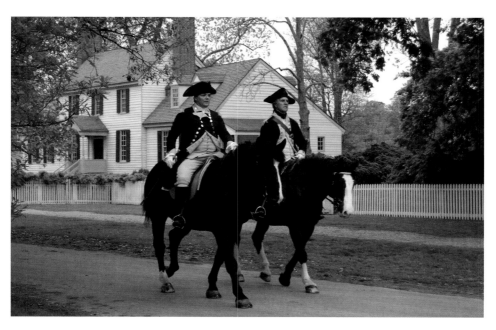

Reenactors on horseback pass in front of the St. George Tucker House on April 27, 2008. This rambling and graceful wooden structure accommodated Tucker's large family. The first Christmas tree in Williamsburg was displayed at house in 1842 by College of William and Mary professor Charles F. E. Minnigerode, formerly of Hesse-Darmstadt, Germany. The house was restored between 1930 and 1931 and Tucker's descendants lived there until 1993. *Harvey Barrison*[19]

This photograph of the Dr. Kate Waller Barrett Memorial Gates at the College of William and Mary was taken on April 30, 1926. The plaque accompanying the gates (visible on the right) was placed there by the Daughters of the American Revolution (DAR) Commonwealth Chapter on that date to honor Barrett, who was a trustee and member of the Phi Beta Kappa (Alpha) chapter at the college, and Virginia state regent of the DAR from 1918 to 1925. The plaque was mounted on a wall next to metal gates from the capitol building in Richmond that were installed outside Jefferson Hall on Jamestown Road at William and Mary. *Sargeant Memorial Collection, Norfolk Public Library*

Dr. Kate Waller Barrett is shown in this November 13, 1922 photograph. *Library of Congress*

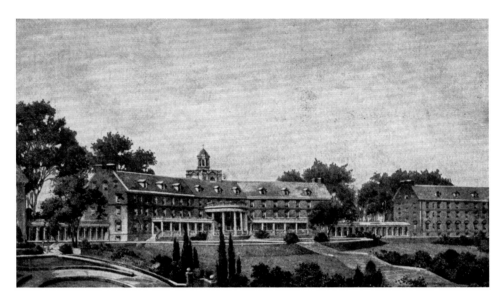

Barrett Hall, located at the intersection of Jamestown Road and Landrum Drive, was named for Dr. Kate Waller Barrett, an educator, humanitarian, sociologist, and the second woman named to the College of William and Mary's board of visitors, making it the first building on the campus named for a woman. Designed by Charles M. Robinson, the college's architect, Barrett Hall was constructed between 1926 and 1927, serving as a women's dormitory from the day it opened until the start of the 2005-2006 school year, when it was converted to accommodate women and men. An architect's rendering of Barrett Hall was published on the postcard shown here in 1927, the year the dormitory was set to open. *Amy Waters Yarsinske*

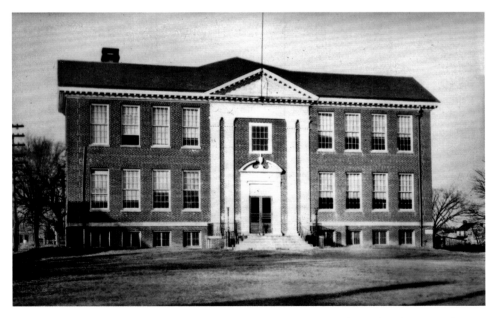

Williamsburg High School, built in 1921, was situated at the north end of Palace Green until it was demolished in 1933 to make room for continued work on the Governor's Palace. During excavation of the palace site, the former high school building became a storage facility for recovered artifacts. The picture was taken in 1926. *Sargeant Memorial Collection, Norfolk Public Library*

49

The public gaol located on the north side of Nicholson Street behind the colonial capitol building was originally constructed in 1704 under the supervision of contractor Henry Cary Jr., of which this portion (shown as it appeared in 1926) was the last surviving building of the original jail complex. During the Civil War, federal troops destroyed the keeper's house and debtors' prison for the bricks and left the jail. The public gaol handled all criminal activity through the nineteenth century. Some of Blackbeard's pirates were held in the old gaol, as well as lieutenant governor and superintendent of Indian Affairs Henry "Hair Buyer" Hamilton, of Fort Detroit, captured during the American Revolution. *Sargeant Memorial Collection, Norfolk Public Library*

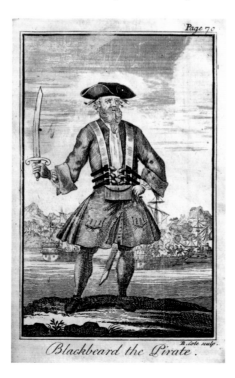

Captain Edward Teach (1680-1718)—Blackbeard—was killed by soldiers and sailors dispatched by Virginia royal governor Alexander Spotswood on November 22, 1718. During the battle that ensued, Teach and several of his crew were engaged by a small force led by Lieutenant Robert Maynard. Others were captured and returned to Williamsburg. Teach is shown in this full-length Benjamin Cole engraving published in 1725. *Library of Congress*

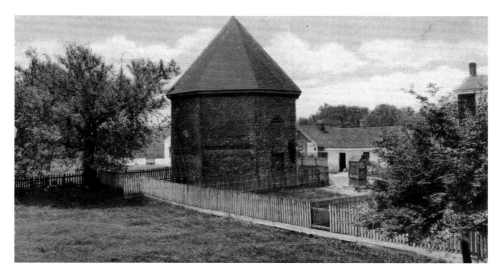

Located on the south side of Duke of Gloucester Street in Market Square between the Palace Green and Queen Street, the magazine (or powder horn) was designed and partly funded by royal governor Alexander Spotswood. The building (shown on this colorized 1910-period postcard) was completed in 1715 as the arsenal for arms and powder sent by Queen Anne to the Virginia colony. John Tyler was the overseer of construction. A brick wall and guardhouse were built during the French and Indian War (1754-1763). After the capital was moved to Richmond in 1780, the building was used for other purposes, including a dance school, market, church and stable. The perimeter wall that had been first built in 1755 was razed in 1856. The magazine was surrounded, just then, by successive nineteenth and twentieth-century buildings prior to restoration. *Amy Waters Yarsinske*

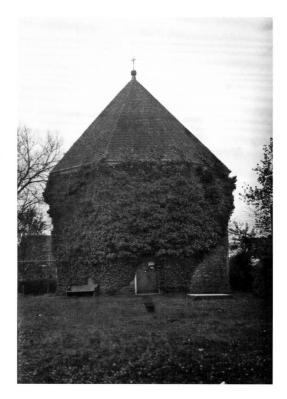

Due largely to the efforts of Cynthia Beverley Tucker Coleman, owner of the St. George Tucker House and a descendant of its namesake, the Association for the Preservation of Virginia Antiquities (APVA) purchased the magazine in 1889. The APVA, cofounded by Coleman, collaborated with the Colonial Williamsburg Foundation between 1934 and 1935 to fully restore the magazine, rebuild the octagonal brick wall and guardhouse. The picture shown here was taken before commencement of that restoration. Charles S. Borjes took this photograph of the magazine (or powder horn) in 1926. *Sargeant Memorial Collection, Norfolk Public Library*

The magazine's guardhouse (shown here), previously lost to the march of progress and subsequently restored, was photographed by Harvey Barrison, of Massapequa, New York, on April 28, 2008. *Harvey Barrison*[20]

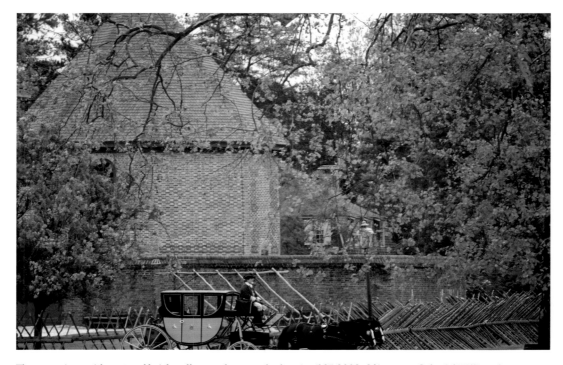

The magazine—with restored brick wall—was photographed on April 27, 2008. Of interest, Colonial Williamsburg Foundation leased the magazine from APVA (now Preservation Virginia) in 1946 and began another restoration. The building opened once again to the public on July 4, 1949. APVA sold the magazine to the foundation in 1986. *Harvey Barrison*[21]

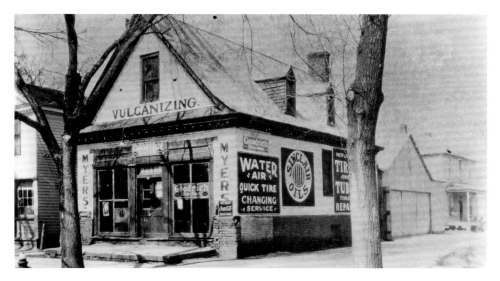

When it was photographed in 1926, the historic Prentis Store on the corner Duke of Gloucester and Colonial Streets was occupied by the Myers garage, an automobile service station. The oldest original store in Williamsburg, it was constructed between 1738 and 1740 by William Prentis, principal in the mercantile firm of Prentis and Company, in business through the American Revolution. The building had more architectural elaboration than most of the commercial buildings in town when first built. It was because the store was constructed so well that it stood out as a colonial period structure when restoration of Williamsburg started. The pedimented roof facing the street is trimmed with a full kick that adds interest to the roof line. The roof structure is trussed, which is unusual in a building of this size. *Amy Waters Yarsinske*

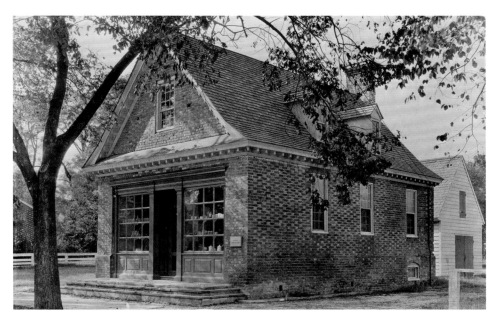

The Prentis Store was restored between 1928 and 1931 (shown here shortly after the first restoration was completed). While the restoration removed the building's twentieth-century appearance, the store's first floor was incorrectly left at ground level, a mistake corrected in 1972 after historical documentation and archaeological investigation revealed that it had a cellar entrance, leading restorers to add a single side-stair porch to the front of the shop. *Library of Congress*

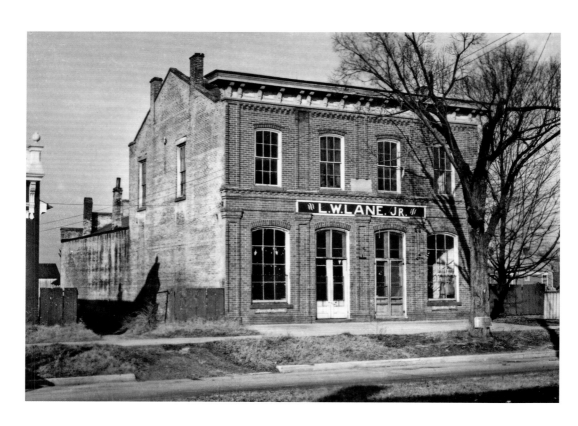

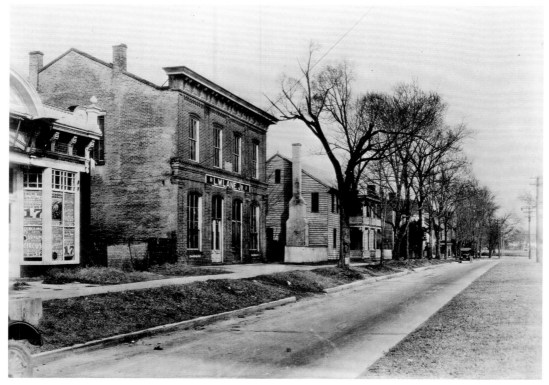

Opposite above: L. W. Lane Jr.'s mercantile store, situated on the north side of Duke of Gloucester Street between Botetourt and Blair Streets, became one of the one hundred buildings slated for demolition or relocation during the Colonial Williamsburg restoration because the architecture dated to a later time period. The store was owned by Levin Winder Lane Jr., who offered a variety of goods from groceries to clothing. The building was originally erected by William W. Vest on the site of the original Raleigh Tavern, which had been destroyed by fire in December 1859. The tavern was the center of the revolutionary activities of the Virginia colony. During the restoration process the former mercantile shop was acquired from Lane and the Raleigh Tavern reconstructed on its original foundation between 1930 and 1931, opening for tours in 1932. The picture was taken in 1926. *Sargeant Memorial Collection, Norfolk Public Library*

Opposite below: The photograph shown here was taken from a lantern slide featuring a pre-restoration scene looking down Duke of Gloucester Street towards the site of the Raleigh Tavern. It is the tenth slide in a set produced by the Pacific Stereopticon Company of Los Angeles, California, now defunct, to illustrate the story of Reverend Dr. William Archer Rutherfoord Goodwin's dream to restore a portion of Williamsburg, Virginia, to its eighteenth-century appearance as a shrine to early American ideals. The former Raleigh Tavern stood where the L. W. Lane Jr. mercantile store is shown in this picture, taken in 1928. The store offered a variety of goods ranging from groceries to clothing. This part of Duke of Gloucester Street was known by residents as uptown or towards the site of the capitol building ruins. *Library of Congress*

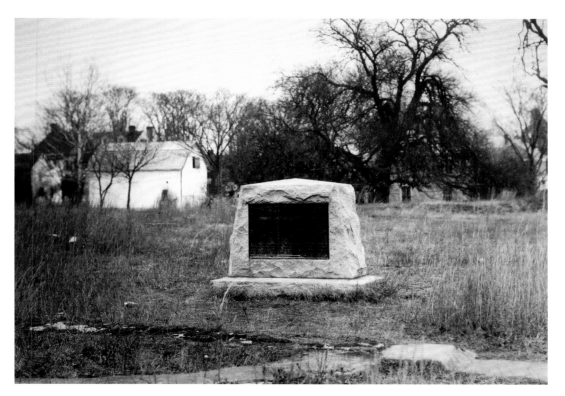

Taken in August 1927, this photograph shows the site of the 1705-1747 capitol that occupied the east end of eighteenth-century Williamsburg's "main street" or the so-called "great street." Today, this is Duke of Gloucester Street. Remains of the building's foundations are clearly visible in the foreground. *Amy Waters Yarsinske*

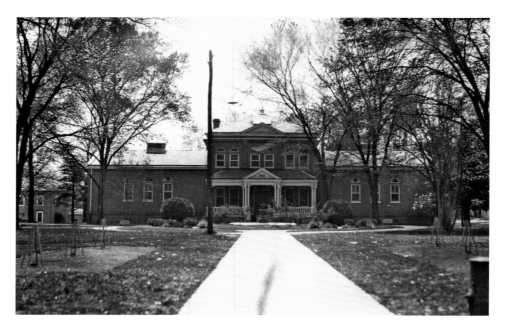

Eastern State Hospital, bordered by Francis, Henry, Ireland and Nassau Streets, was photographed by Charles S. Borjes in 1928. The hospital first opened on September 14, 1773, in Williamsburg when Virginia was still a British colony. Eastern State was the first public facility in the United States constructed solely for the care and treatment of the mentally ill. In 1935, the facility had about 2,000 patients but no additional land for expansion. With the restoration of Colonial Williamsburg and development of the Williamsburg Inn, the hospital was no longer compatible with the city's blossoming tourist trade. Between 1937 and 1968 all of Eastern State's patients were relocated to a new facility on the outskirts of Williamsburg. *Sargeant Memorial Collection, Norfolk Public Library*

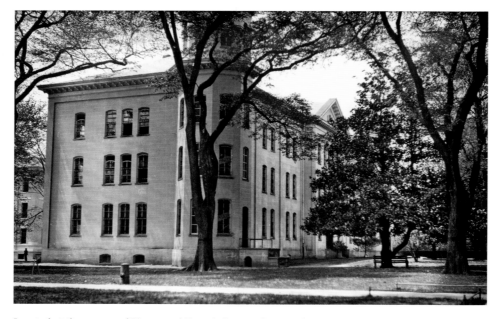

Located at the corner of Henry and Francis Streets, Eastern State Hospital's Thurman Building was photographed in 1928. *Sargeant Memorial Collection, Norfolk Public Library*

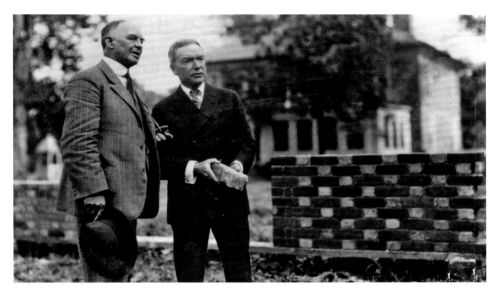

Reverend Dr. William Archer Rutherfoord Goodwin (left) and John D. Rockefeller Jr. were photographed on October 19, 1928, inspecting restoration work underway on which Rockefeller had already spent five million dollars. Twice rector of Bruton Parish Church, and department chair at the College of William and Mary, Goodwin has been described as consumed by his life's work to save Williamsburg from the march of time. Goodwin was the man who stoked the fires of Rockefeller's passion to restore the cradle of America's liberty. They were the dynamic duo who delivered Williamsburg from oblivion. *Amy Waters Yarsinske*

This small house—a dependency— was given by Clarence F. Casey to John D. Rockefeller Jr. to facilitate Rockefeller's restoration initiative. Casey was a farmer who lived on the north side of Duke of Gloucester Street. When this picture was taken on August 11, 1928, Rockefeller was already aggressively buying and restoring the town and this was the only property just then that had been given to him during the restoration of the city. *Amy Waters Yarsinske*

The George Jackson residence was photographed in the 1920s as part of the Historic American Buildings Survey, an initiative to create a record of structures that in many cases were about to be demolished, as this home was in or about 1933. Merchant Jackson was a resident of Norfolk, Virginia, until he moved to Williamsburg in 1773/4, purchasing the 1767 house and attached store with its York Street lot from Lewis Hansford. Though Jackson died in 1794, he spent the decade prior to his death modifying and making repairs to the building. The house was documented by Colonial Williamsburg architects in 1928, though the foundation did not acquire the property on which it once stood until 1939. The George Jackson house and store was reconstructed in 1954 on its original site on the north side of Francis Street, at the east end of the historic area. *Library of Congress*

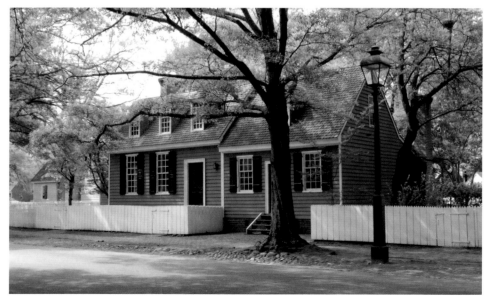

The George Jackson House, shown here as it looked on April 26, 2008, was recreated on its original plot of land on the north side of Francis Street. *Harvey Barrison*[22]

Lady Nancy Witcher Langhorne Astor visited Williamsburg as the guest of John D. Rockefeller Jr. Astor was photographed standing in front of the first house to be completely restored—the Lottie C. Garrett residence (today the Coke-Garrett House) on the east end of Nicholson Street north of the capitol building—on October 24, 1928. The Coke-Garrett House was one of the 88 original structures from the eighteenth and very early nineteenth century still standing when restoration of Williamsburg was undertaken starting in the late 1920s. The Coke-Garrett property was owned by goldsmith and tavern keeper John Coke and his heirs from 1755; the Garrett family owned the property for more than a century, starting in 1810, expanding the house with the construction of the center section between 1836 and 1837. *Amy Waters Yarsinske*

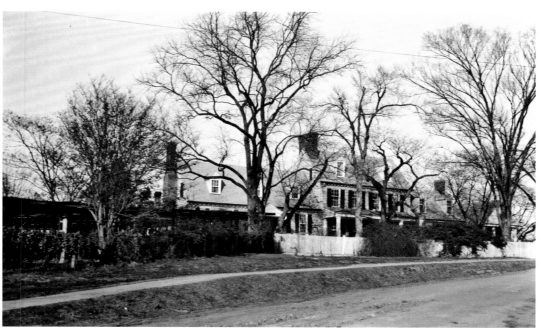

The Coke-Garrett House was photographed in 1933, five years after Lady Astor's visit and after the Colonial Williamsburg restoration was well underway. *Library of Congress*

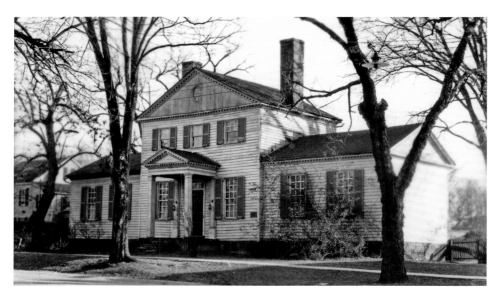

Charles S. Borjes took this photograph of the William Finnie House, located at 506 Francis Street and while date of construction is imprecise, the house did show up on the 1782 Frenchman's Map. William Finnie served as the quartermaster general of the Southern Department of the Continental Army during the American Revolution and was the mayor of Williamsburg from 1783 to 1784; it is known that he lived in the house during the war. This fine residence was also known as the James Semple House. Semple came to own the property in the early nineteenth century. Finnie's home was one of the first acquired for restoration in 1928 (also the year the picture was taken). Restoration was completed in 1932. *Sargeant Memorial Collection, Norfolk Public Library*

The John Bracken House (shown here just after the 1928 restoration), located on the southeast corner of Francis and Queen Streets, is believed to have been built before the Revolutionary War, presumably between 1760 to 1770. Bracken (1745-1818) was the rector of Bruton Parish Church from 1773 until his death; he married Sally Burwell, daughter of Carter Burwell, owner of Carter's Grove, in 1776. Bracken achieved his greatest distinction as the ninth president of the College of William and Mary (1812-1814), succeeding the Right Reverend Dr. James Madison. *Library of Congress*

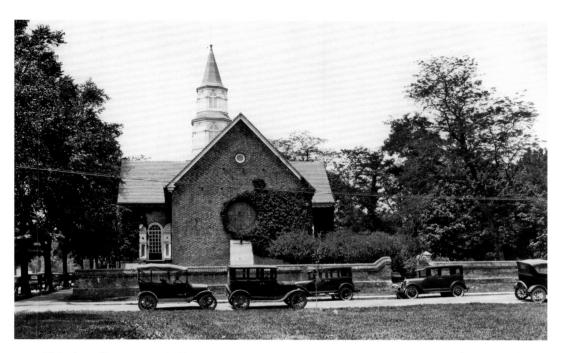

This view of Bruton Parish Church was taken in or about 1930 from the Palace Green (foreground). *Amy Waters Yarsinske*

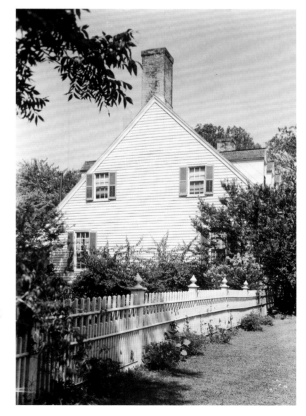

Located on the northwest corner of Francis and Botetourt Streets, the Dr. Philip Barraud House likely dates from the third quarter of the eighteenth century. According to Colonial Williamsburg Foundation documentation, the original brickwork and framing indicated that the house was built it two distinct phases, the earliest, double-pile section closest to the corner of the two streets with a smaller ten-foot addition to the west. Thus, it is plausible that William Carter, an apothecary, or blacksmith James Anderson erected the building as rental property in the 1760s or 1770s. The Frenchman's Map of 1782 confirms the presence of what appears to be the earliest iteration of a structure standing on the site. The house reached its present dimension by 1796, when it was expanded by Dr. Barraud, who owned the home from 1785 to 1801. Barraud was a physician at the public hospital in Williamsburg until he became director of the marine hospital in Norfolk, Virginia, in 1799. The house was photographed in 1933 as part of a Historic America Buildings Survey. *Library of Congress*

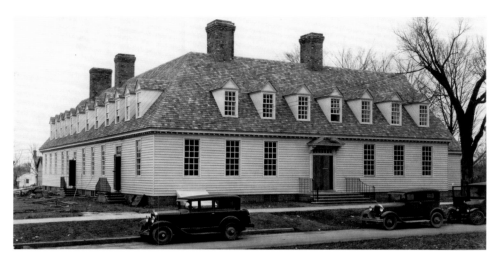

The Raleigh Tavern was rebuilt by John D. Rockefeller Jr. on the foundations of the original public house established in 1717. According to Colonial Williamsburg, when the restoration of the historic city began in 1926, two modern brick stores (to include L. W. Lane Jr.'s mercantile store) stood on the site. Archaeological excavations begun in 1928 by the Williamsburg Holding Company (a forerunner of Colonial Williamsburg) unearthed the foundations and artifacts. Drawings from Benson J. Lossing's book, *A Pictorial Field-Book of the American Revolution*, and insurance policy sketches permitted precise reconstruction. Eighteenth-century inventories informed the tavern's refurnishing. The tavern was photographed under construction in December 1929; it was not dedicated until September 16, 1932. *Amy Waters Yarsinske*

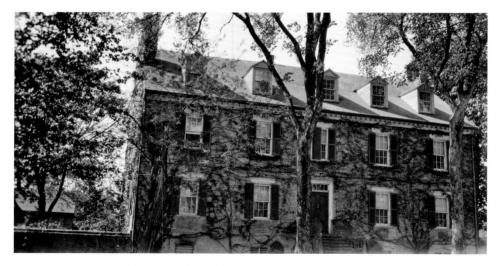

The Palmer House, one of the original 88 buildings in the Colonial Williamsburg historic area, is situated on the south side of Duke of Gloucester Street near Capitol Square and is shown here as it appeared in 1933. Lawyer and College of William and Mary treasurer John Palmer built the first iteration of this home in 1754, a far smaller and off-center front-door residence later rendered unrecognizable by additions and modifications, including an 1857 expansion that pulled the front-door to the center and gave the house symmetry. The house was restored to Palmer's original footprint in 1952. Palmer House was used for the headquarters of Confederate generals John B. Magruder and Joseph E. Johnston during the Battle of Williamsburg in May 1862. Following the battle and Confederate withdrawal toward Richmond, it was used as headquarters for Union general George B. McClellan and Federal Provost Marshall lieutenant William W. Disoway. *Library of Congress*

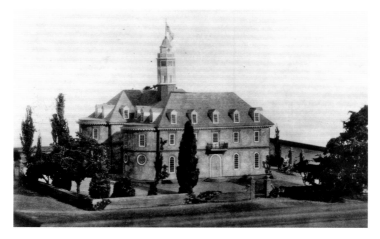

The building that stands now in Colonial Williamsburg is the third capitol building on that site. Early in the twentieth century, Reverend Dr. William Archer Rutherfoord Goodwin undertook restoration of historic Bruton Parish Church, built between 1710 and 1715, where he was then rector. Goodwin's life's mission of restoring other buildings of the old colonial capital city led to his affiliation with Standard Oil heir and philanthropist John D. Rockefeller Jr. and the creation of Colonial Williamsburg. The reconstructed 1705-1747 capitol and Governor's Palace join the Wren Building of the College of William and Mary as the three main structures of the restoration. A model of the capitol building was photographed on December 13, 1930, just ahead of the start of construction on the building's original foundations. The capitol restoration was the forty-sixth such structure undertaken in the complete rebuilding of the city. At that time, the Governor's Palace and the first theater in America were among projects that had not yet started. *Amy Waters Yarsinske*

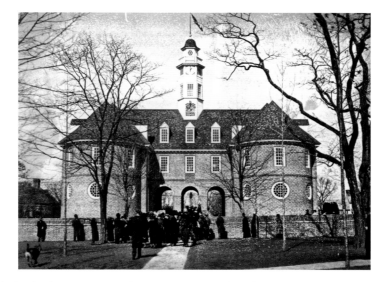

The Association for the Preservation of Virginia Antiquities (APVA) deeded the grounds of the ruins of the colonial capitol to Colonial Williamsburg Foundation in 1928, which reconstructed the capitol of 1705-1747. The architecture was more interesting than that of the second capitol, and it was better documented. Refurnished with the help of eighteenth-century records, the new capitol was dedicated with a ceremonial meeting of the Virginia General Assembly on February 24, 1934, captured in this photograph by Charles S. Borjes. Since that time, the legislators have reassembled for a day every other year in the tall brick building at the east end of Colonial Williamsburg's historic area. *Sargeant Memorial Collection, Norfolk Public Library*

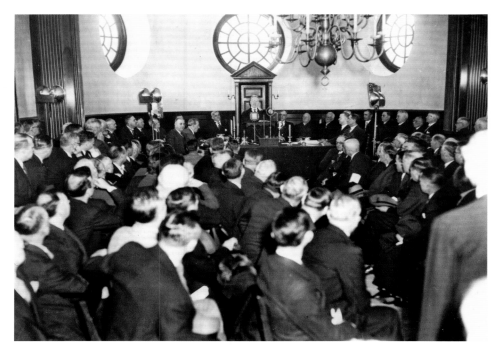

John D. Rockefeller Jr. (at the microphone) addressed the meeting of the Virginia General Assembly in the restored Williamsburg capitol building on February 24, 1934, the first meeting of the assembly away from Richmond, Virginia, since 1781. *Amy Waters Yarsinske*

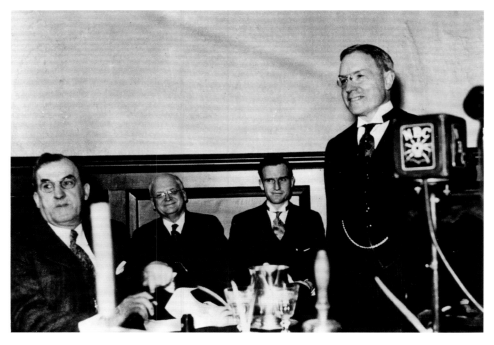

During the dedication of the reconstructed capitol building, John D. Rockefeller Jr. (far right) took center stage before the Virginia General Assembly on February 24, 1934, lauded for his vision and philanthropy in the restoration of Colonial Williamsburg. *Amy Waters Yarsinske*

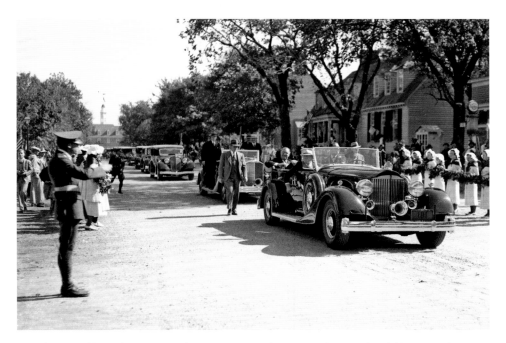

President Franklin Delano Roosevelt's motorcade makes its way down Duke of Gloucester Street on October 20, 1934. The president was in Williamsburg to receive an honorary doctorate degree from the College of William and Mary. *Sargeant Memorial Collection, Norfolk Public Library*

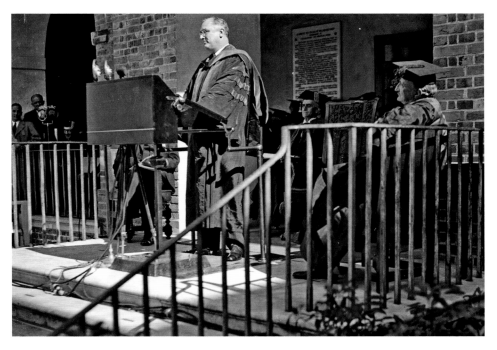

President Franklin D. Roosevelt addressed the large crowd gathered to witness his receipt of his honorary doctorate but also the installation of John Stewart Bryan as president of the College of William and Mary. The October 20, 1934 event was held on the steps of the Wren Building. *Sargeant Memorial Collection, Norfolk Public Library*

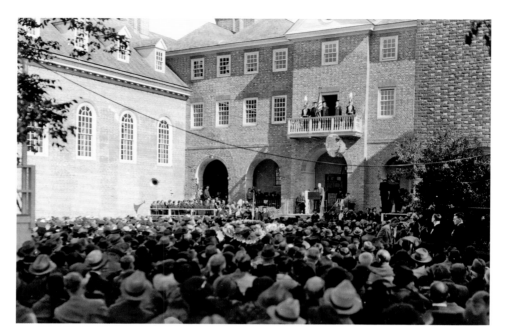

Throngs of onlookers watched President Franklin Roosevelt receive his honorary doctorate and the installation of John Stewart Bryan from the Wren Building's courtyard. Roosevelt is at the podium in this photograph. *Sargeant Memorial Collection, Norfolk Public Library*

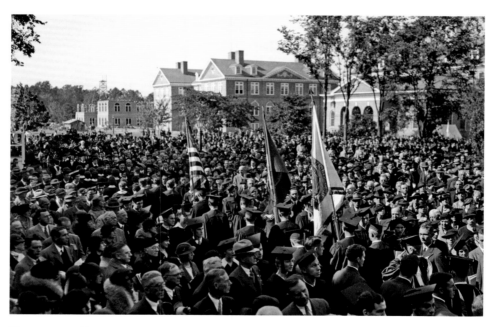

The recessional following John Stewart Bryan's installation as president of the College of William and Mary was photographed on October 20, 1934. James Blair Hall, formerly called Marshall-Wythe Hall, was under construction when this picture was taken. Located on the west end of the future Sunken Garden, it was built with a Public Works Administration (PWA) grant and was initially intended to house the Marshall-Wythe School of Government and Citizenship. The renaming occurred in 1968. *Sargeant Memorial Collection, Norfolk Public Library*

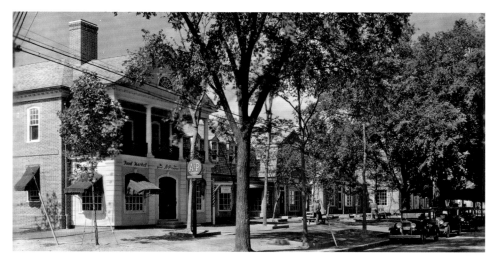

Built between 1931 and 1932, the A & P Grocery (the building's first occupant in November 1932 and pictured foreground as it appeared in the early 1930s), later the Craft House, Fat Canary and Cheese Shop, remains an anchor structure along the western group of commercial tenant spaces on the south side of Duke of Gloucester Street in Merchants Square. The building, just west of the Williamsburg Inn, was designed by Perry, Shaw and Hepburn architects and the Colonial Williamsburg Architect's Office. A remarkable number of talented designers worked on the plans, including William G. Perry, Arthur A. Shurcliff, George Campbell, Washington Reed, and Singleton P. Moorehead. Moorehead was the foundation's most talented architect working in Williamsburg from the late 1920s until his 1960 retirement; he came to town as part of the Perry, Shaw and Hepburn team in 1929. Moorehead and others cast the Craft House as an 1800-1820 Virginia or mid-Atlantic house. This continued the theme of the nearby inn. *Amy Waters Yarsinske*

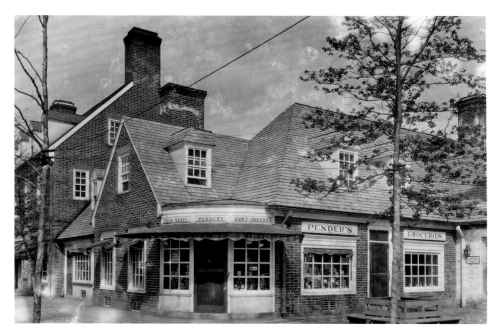

Today's Toymaker of Williamsburg Shop on Duke of Gloucester Street in Merchants Square was originally Pender's grocery store when it was built between 1929 and 1931. The picture was taken shortly after the Pender's opened in this location. *Amy Waters Yarsinske*

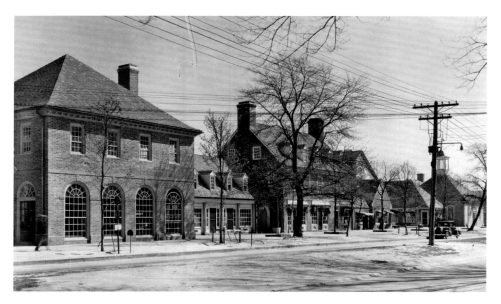

Built between 1930 and 1931, and designed by Perry, Shaw and Hepburn, with a later north addition by Glavé and Holmes in 1965, the building in the foreground (left) at College Corner on the western end of Duke of Gloucester Street in Merchants Square is shown shortly after the building was completed. The building was subsequently occupied by Binns Fashion Shop. *Amy Waters Yarsinske*

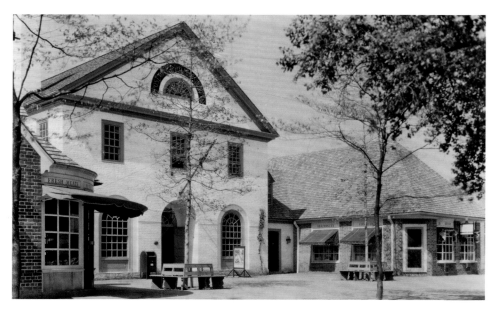

The first post office in Merchants Square was built between 1929 and 1931 and is shown here as it looked just after completion. Though the present-day building is of light reddish-brown brick with worn whitewash, the entire building was painted white when first constructed. Called the Arcade Building, its name was predicated on what was once an open round-headed front doorway (now enclosed with a door leaf) flanked by a pair of round-headed shop fronts. The Christmas Shop occupies the southwest corner. Four smaller shops and offices occupy the rear of the two-story building. An ensemble of buildings on the north side of Duke of Gloucester Street are connected to the Arcade Building by an open-air passage covered by a pitched roof. The Pender's grocery store is to the left (foreground). *Amy Waters Yarsinske*

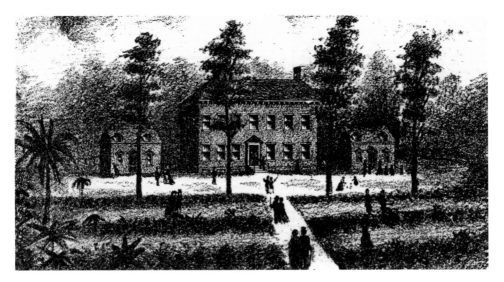

Carter's Grove, located just six miles from Williamsburg, was built by Carter Burwell, grandson of Robert "King" Carter, between 1750 and 1753. David Minetree, a Williamsburg brick mason, was the master builder; John Wheatley of Williamsburg was the carpenter. Richard Baylis was brought from England in 1752 to complete the interior woodwork. The Burwell family owned Carter's Grove until 1838. This engraving of Carter's Grove dates to 1880. Note that the dependencies on either side stand separated from the main house. *New York Public Library*

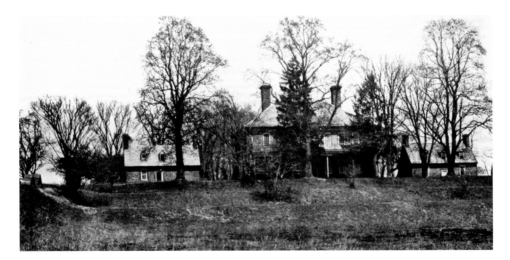

Edith Dabney Tunis Sale first published this picture of Carter's Grove in her *Manors of Virginia in Colonial Times*, published by J. B. Lippincott, of Philadelphia and London, in 1909. She wrote that the estate was "whitened in April by dogwood and sheeted with arbutus, violets and frail anemones, while the gorgeous yellow jessamine, that first flower of the South, flings its golden streamers from limb to limb of the smallest shrubs and greatest trees. One is in the midst of a riot of sweet-scented color," she continued, "which fades only when the lawn is reached. Crossing a picturesque ravine, the broad driveway merges into an avenue about one quarter of a mile in length, bordered by cedars of magnificent growth which spring from the thick turfing. Just before the grounds are entered, the cedar avenue gives place to one of locusts, which continues through a wonderful grove of the same graceful trees to the circular stone steps on the north front. The substantial brick dwelling is situated directly on the James [River], upon a high bluff, and commands a very beautiful water view." *Library of Congress*

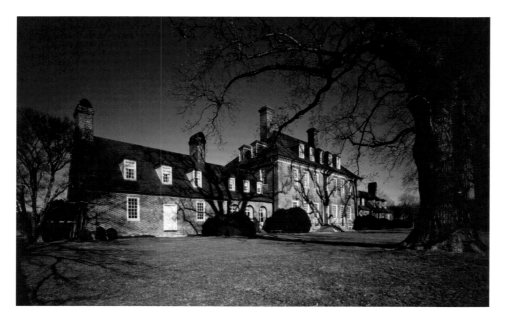

Above: Carter Burwell's magnificent mansion and plantation belonged to a succession of owners after it passed out of his family, to include Thomas Percival Bisland (1865-1908), who connected the kitchen to the main house and made other alterations in 1907. Archibald Montgomery McCrea and his wife, Mary Corling Johnston Dunlop McCrea, originally of Petersburg, Virginia, bought the mansion in 1928 and promptly had Richmond architect W. Duncan Lee (1884-1952) raise the roof, add a third floor, widen the kitchen and office, and connect both dependencies to the main house. Archibald McCrea (1876-1937) was a noted Yale University football player and the son of James Alexander McCrea, president of the Pennsylvania Railroad. A Pittsburgh industrialist and president of the Union Springs Manufacturing Company, Archibald McCrea's time at Carter's Grove was cut short by his death. Jack E. Boucher took this exterior color photograph of Carter's Grove in 1975 during an Historic American Buildings Survey (HABS) conducted with the cooperation of the foundation. *Library of Congress*

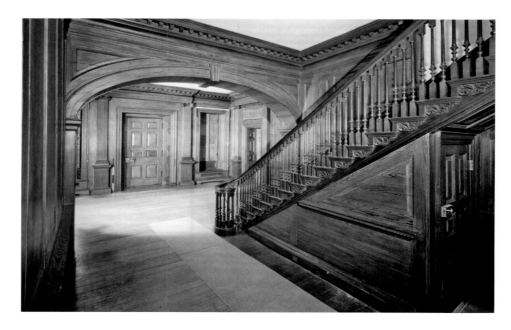

Opposite below: The Carter's Grove main hall and part of the first-floor stairwell was photographed looking southwest for the Historic American Buildings Survey conducted in conjunction with the Colonial Williamsburg Foundation in 1975. Up to the time it was modernized, Carter's Grove was fortunate in escaping any but minor changes and was undoubtedly the most important architectural survivor of the eighteenth-century Virginia architecture, according to architect Thomas T. Waterman (1900-1951), who documented the property in the spring of 1941. *Library of Congress*

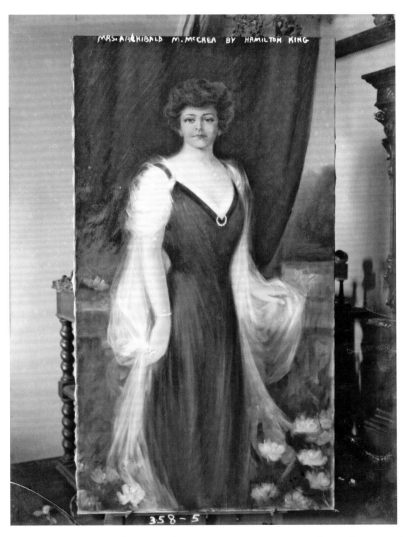

Mary Corling Johnston McCrea (1876-1960), affectionately known as Mollie McCrea, continued to live at Carter's Grove another twenty-three years after her husband passed away. The property was purchased by the Colonial Williamsburg Foundation from Mollie McCrea's estate after she died. This portrait of Mollie McCrea by Hamilton King (1871-1952), renowned for his female illustration art that graced magazines covers, advertising (famously Coca-Cola), and cigarette cards, was photographed by the Bain News Service and dates to the fall of 1911 when she sat for King. Prior to her September 30, 1911 marriage to Archibald McCrea, she was married to elderly tobacco magnate David Minge Dunlop (1832-1909), who left her close to $2 million and his tobacco enterprise at the time of his death but only if she remained his widow for the remainder of her natural life—a condition that became untenable when she fell in love with McCrea. *Library of Congress*

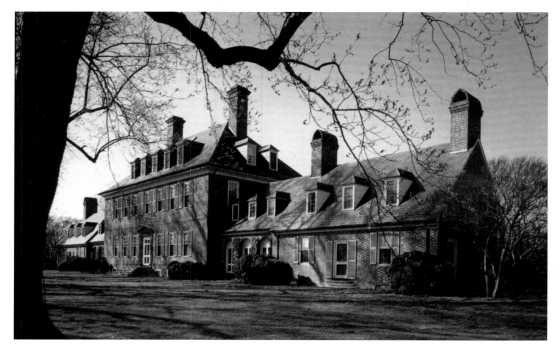

Architectural historian Samuel Chamberlain once called Carter's Grove "the most beautiful house in America." The postcard shown here dates to the period just after the Colonial Williamsburg Foundation took ownership of the property. *Amy Waters Yarsinske*

Writer Gertrude Stein (1874-1946) was photographed on the lawn at Carter's Grove on February 8, 1935, by Carl Van Vechten (1880-1964). At the time of her visit, the mansion was occupied by the McCreas. *New York Public Library*

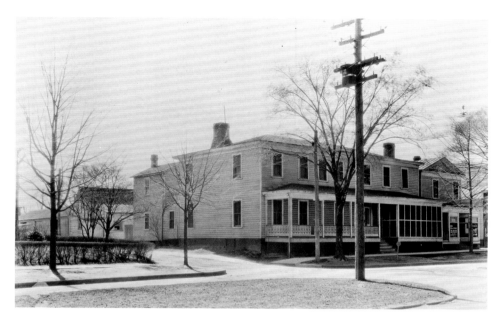

The before-and-after of the Market Street Tavern serve as a dramatic example of history hiding under the nineteenth- and twentieth-century modifications determined to make everything old, new again. Colonial Williamsburg documentation indicates that Dr. John Dixon leased the land on which the tavern was built from the city per a deed dated July 3, 1749, but there is now direct evidence that he constructed a building on the lot. The property passed to Thomas Craig, a tailor, who operated a public house that took in lodgers, according to the February 19, 1767 *Virginia Gazette*. Gabriel Maupin acquired the tavern in 1771 and enlarged it. The before photograph was taken just prior to restoration, which took place between 1931 and 1932. During that restoration, the second floor was removed and the floor levels returned to their original position. Rockefeller's architects relied on colonial pattern books to complete the tavern's cornices, dormers and other exterior features. The after photograph was taken by Fay S. Lincoln in 1935. *Library of Congress (top), Cornell University Library (bottom)*

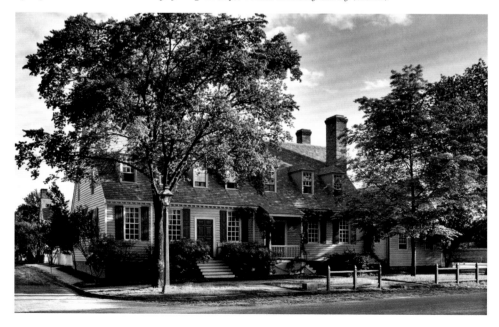

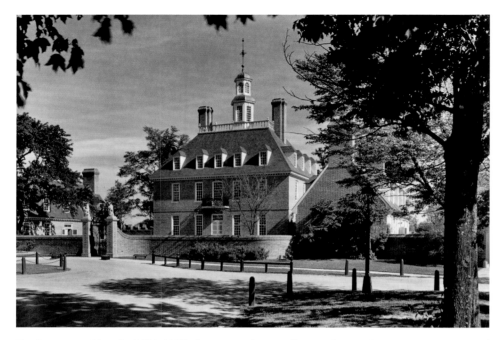

Fay Sturtevant Lincoln (1894-1976), known professionally as F. S. Lincoln, was an architectural photographer active from the 1930s to the 1950s in New York City and Long Island, New York, and with commissions in Charleston, South Carolina, and Williamsburg, Virginia. He also took jobs in France and several states in the American South. In 1935, Lincoln was called to Colonial Williamsburg to record the results of the restoration first begun by John D. Rockefeller Jr. This photograph of the Governor's Palace was taken by Lincoln as part of that trip to the eighteenth-century capital of Virginia. *Cornell University Library*

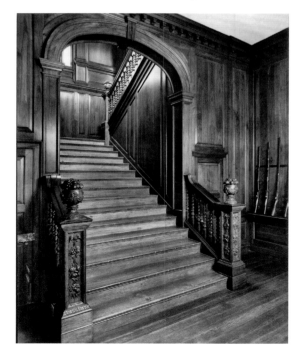

Photographer Fay S. Lincoln's commission to photograph the Colonial Williamsburg restoration resulted in hundreds of photographs, of which this picture of the Governor's Palace main staircase is one of dozens taken of this building, completed over a three-year period from 1931 to 1934. *Pennsylvania State University Library*

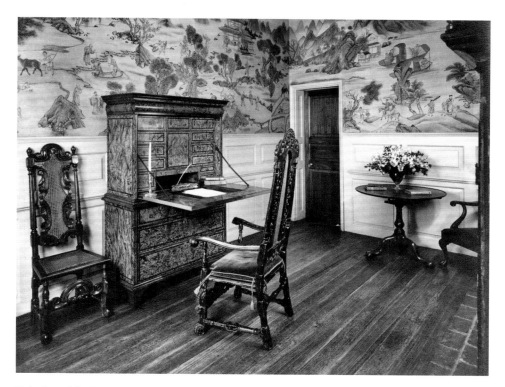

This view of the Governor's Palace study was taken by Fay S. Lincoln. *Pennsylvania State University Library*

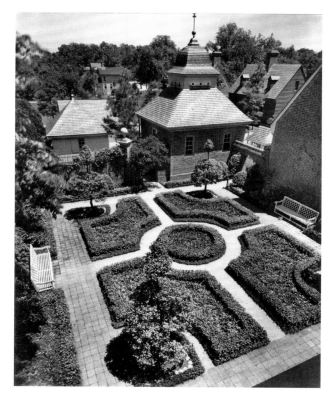

The restoration of Colonial Williamsburg included historic gardens that dotted the landscape in the seventeenth and eighteenth centuries. The availability of land in Williamsburg (and in all of the colony's colonial towns) provided colonists the opportunity to develop both sophisticated and practical landscapes around their homes, public buildings and business establishments. This is a view of the holly garden at the Governor's Palace, taken by Fay S. Lincoln in 1935. *Pennsylvania State University Library*

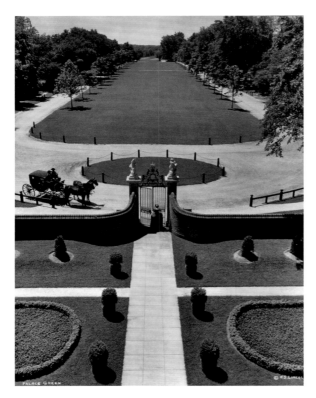

According to Colonial Williamsburg's information on the Palace Green (shown here), when Governor Francis Nicholson drafted the plan for Williamsburg in 1699, he arranged the streets and spaces with deference given to the relationships of purpose and power in the colony's new capital. Thus, the city's main north-south axis commands twice the breadth of its central east-west streets and continues some 900 feet to the gates of the Governor's Palace. The Palace Green was intended to focus the eye as well as the mind on the source of executive authority in Virginia and to give the stately official residence an unimpeded vista to community beyond and all around it. This picture was taken by Fay S. Lincoln, also in 1935, and from his photographer's perch, he captured the view Virginia's colonial governors would have had from the residence. *Cornell University Library*

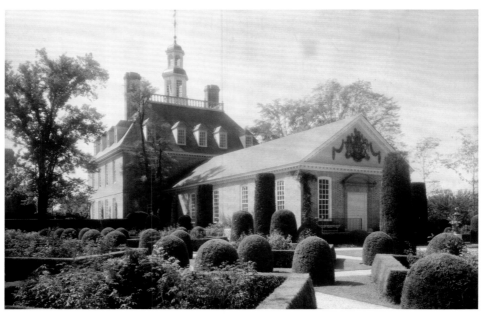

Frances Benjamin Johnston (1864-1952) took this photograph of the Governor's Palace garden between 1930 and 1939 as part of the Carnegie Survey of the Architecture of the South. During this project, Johnston created a systematic record of early American buildings and gardens with the intent to help preserve and inspire interest in American architectural history. The Carnegie Corporation became her primary financial supporter and provided six grants to her in the 1930s. *Library of Congress*

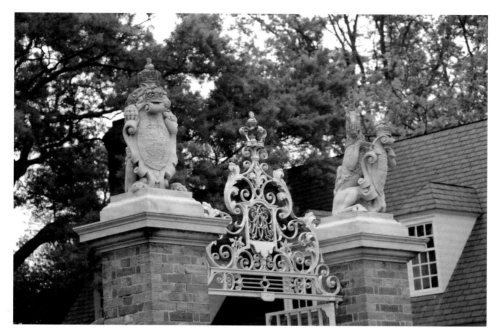

The Governor's Palace main gate, photographed by Harvey Barrison, of Massapequa, New York, on April 27, 2008, features the lion (left) and unicorn (right), integral to the overall royal coat of arms present here and throughout the palace building. The lion, the symbol of England, and the unicorn, famously representative of Scotland, are both made of stone. *Harvey Barrison*[23]

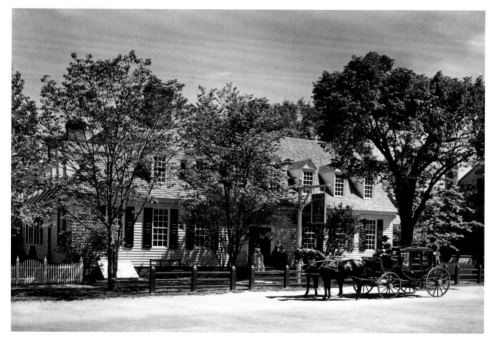

Raleigh Tavern, restored by Colonial Williamsburg, was photographed by Fay S. Lincoln as part of his commission to document the efforts of Reverend Dr. William Archer Rutherfoord Goodwin and John D. Rockefeller Jr. to bring back the cradle of the nation's history. *Cornell University Library*

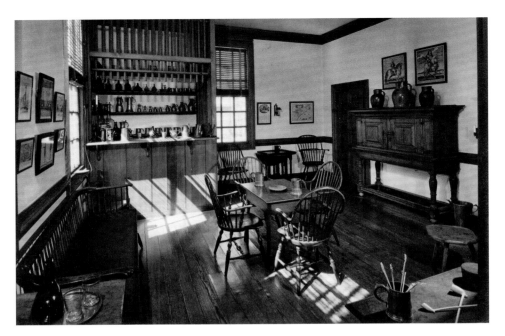

Fay S. Lincoln took this interior photograph of restored Raleigh Tavern in 1935. *Pennsylvania State University Library.*

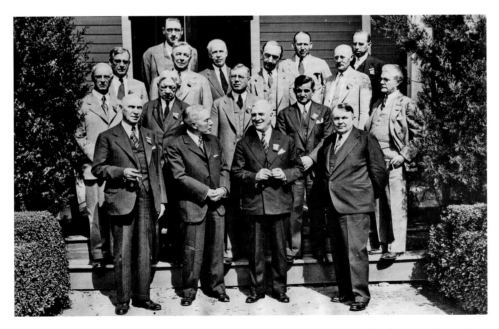

John D. Rockefeller Jr. was honored by the American Institute of Architects (AIA) at a luncheon given in his honor on May 10, 1936, at the Williamsburg Inn. The AIA chose Rockefeller for the honor "in recognition of the great historical values preserved by the restoration of Colonial Williamsburg through the vision, direction and generosity of John D. Rockefeller Jr." The photograph shows members of the AIA board of governors on the steps of the inn (left to right, front row): Louis LaBeaume, of Saint Louis, Missouri, first vice president; Rockefeller; Stephen F. Voorhees, of New York, president, and Edwin Bergstrom, of Los Angeles, treasurer. *Amy Waters Yarsinske*

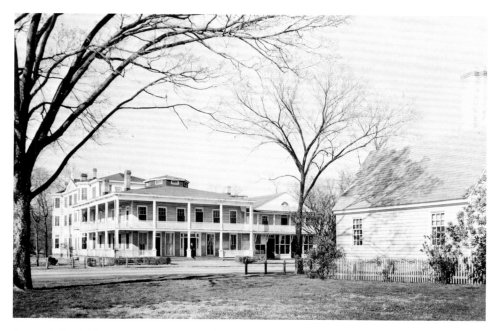

Spencer's Hotel (also called the Colonial Inn) was photographed in or about 1915. The hotel's proprietor, John Branch Clopton "Jack" Spencer (1853-1944), is standing on the porch. This hotel was the result of three building periods, the earliest of which dated to 1840 and would have been the central or southwest part unit; an 1890 to 1900 addition included a ballroom. Spencer was last listed as proprietor of the hotel in the 1920 census. Shortly after, he became ill and was sent to Western State Hospital in Staunton, Virginia, where he died. The hotel was razed in 1938. *Library of Congress*

The Governor's Palace gardens are divided into outdoor "rooms" within ten enclosed acres. The ballroom garden is shown in this picture, taken on April 4, 1938. *Amy Waters Yarsinske*

Williamsburg Restaurant was an iconic eatery on College Corner, where Jamestown and Richmond Roads meet North and South Boundary Streets, where Duke of Gloucester Street ends—or begins—and where the College of Williams and Mary campus begins. The restaurant is shown on this 1940 period postcard. *Amy Waters Yarsinske*

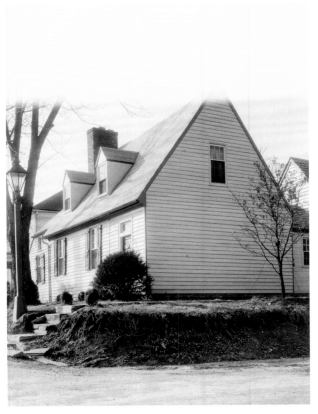

The Captain William Timson House (also called the "Little Christian House"), located on the corner of Prince George and Nassau Streets and photographed for a Historic American Buildings Survey (HABS) report published on May 19, 1941, is generally credited with being one of the oldest houses in Williamsburg. According to historic records, on March 17, 1713/4, Timson, a wealthy planter from Queen's Creek, was deeded lot number 323 from the trustees of the city of Williamsburg and built a one-story frame house in 1716. The following year he sold the residence to tailor James Shields. The Shields family lived there until 1745, when it was sold to carpenter James Wray. The house passed through several owners from the Revolutionary War through the early twentieth century, when it was purchased by Reverend Dr. William Archer Rutherfoord Goodwin in the late 1930s. Of note, the house was not sold to Colonial Williamsburg until 1969, and it was renovated in 1996. *Library of Congress*

When Thomas T. Waterman prepared his report on the Peyton Randolph House dated May 19, 1941, it was accompanied, in part, by this photograph of the home's exterior. But as Colonial Williamsburg researchers later discovered, it was just two-thirds of what had been a three-structure configuration that included a 1715 square two-story west wing; a one-and-a-half story east wing built prior to 1724, and a center section to bring west and east wings together, completed in 1753. The house first fronted England Street but was subsequently reoriented to face Market Square. Records indicate that the east wing was gone by 1783, only to be reconstructed in 1933. The house famously belonged to Virginia's first knight and speaker of the House of Burgesses, the lawyer Peyton Randolph, who acquired the property in 1724. *Library of Congress*

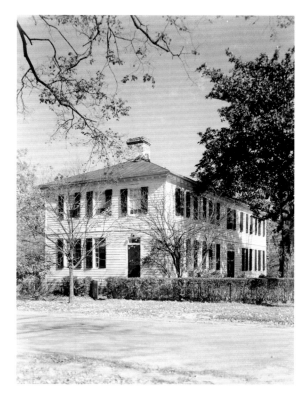

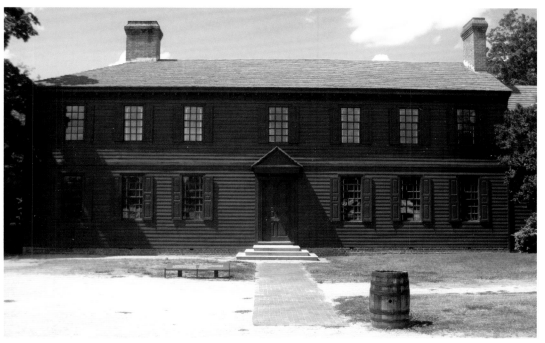

The Peyton Randolph House, restored to its original appearance, was photographed on June 28, 2008.[24] The home's east wing (right) was reconstructed in 1933. Randolph's stature made his home the destination point for Virginia's power brokers, to include Founding Father Thomas Jefferson.

A group of United States Army soldiers from the Eleventh Battalion, Coast Artillery Corps, garrisoned at Fort Eustis, Virginia, were photographed on August 17, 1941, during a visit to Colonial Williamsburg. Here, they are shown emerging from the Governor's Palace gate. *Amy Waters Yarsinske*

The weapons collection displayed in the Governor's Palace includes 230 muskets—80 of them original—and 300 reproduction swords and 18 reproduction pistols. This photograph, taken on December 28, 2008, by Humberto Moreno, shows just a small part of the palace weaponry on display and even smaller peek at the Colonial Williamsburg Foundation's broader 400-year-old collection of weaponry. *Humberto Moreno*[25]

While visiting Colonial Williamsburg, army soldiers of the Eleventh Battalion, Coast Artillery Corps, from Fort Eustis, Virginia, stopped to tour the public gaol located on East Nicholson Street. Soldiers with their heads in the stocks are identified as Daniel Reilly (left), of New York City, and Andrew C. Jaremka (right), of Buffalo, New York. *Amy Waters Yarsinske*

The army's Eleventh Battalion, Coast Artillery Corps, visiting Colonial Williamsburg from nearby Fort Eustis, was the subject of a series of photographs taken on August 17, 1941, for newspaper publication. In this picture, soldiers put a couple of their comrades in foot stocks at the public gaol on East Nicholson Street. *Amy Waters Yarsinske*

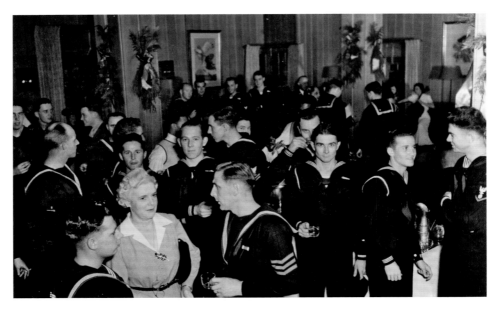

Abby Aldrich Rockefeller, wife of John D. Rockefeller Jr., attended a Christmas party with Royal Navy and United States Navy sailors at Williamsburg, Virginia, on December 24, 1941. *Naval History and Heritage Command*

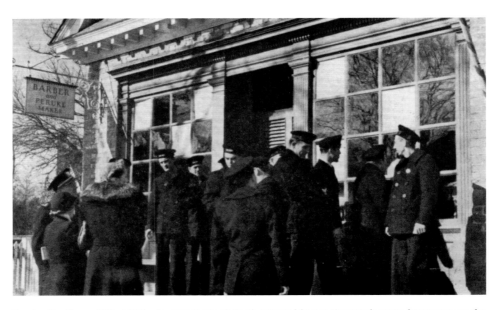

During the Second World War, beginning in 1942, the United States Navy took over a large area on the north side of the Virginia Peninsula in York County, Virginia, which became known as Camp Peary, initially for use as a Seabee training base. The Chesapeake and Ohio Railway (C & O) extended a spur track from its Richmond-Newport News main line track to the site from nearby Williamsburg, and established Magruder Station near the former unincorporated town of Magruder. All residents of Magruder—named for Confederate general John B. Magruder—and Bigler's Mill had to vacate to convert the property to a military reservation. Seabees from Camp Peary were photographed visiting Colonial Williamsburg's Barber and Peruke Maker (the occupant just then of the William Prentis Store) on Duke of Gloucester Street in 1942. *Amy Waters Yarsinske*

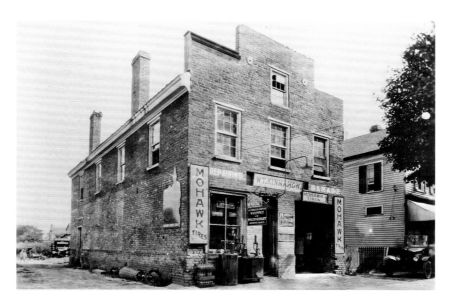

This is the eighteenth-century Margaret Hunter Millinery Shop in 1930, built as a one-and-a-half story building fronting Duke of Gloucester Street between 1735 and 1755 and unrecognizable before the first of two restorations to bring it back to the building's original appearance. At the time the picture was taken, the building was occupied by the W. T. Kinnamon garage, purveyor of Mohawk tires, owned and operated by Wilson T. Kinnamon. *Library of Congress*

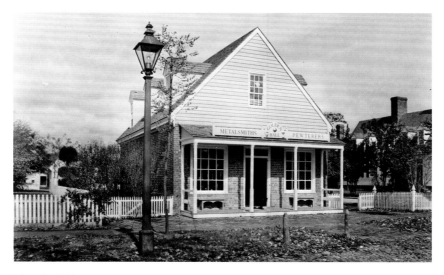

After the 1930 restoration, the Margaret Hunter Millinery Shop gained large shop windows, a front porch and rear wing. The east and west walls and the foundations are the only original features to period. The storefront was rented to the Pender Grocery Company until 1937 when it became the Golden Ball (shown here). The Golden Ball relocated in 1951 to its original site and the building was restored to one of its original functions—an eighteenth-century milliner's shop. At that time, the wooden façade, porch and rear wing were removed and the entrance elevated to its original level at the water table. The Margaret Hunter Shop opened in January 1954, and has remained unaltered since that time. The shop is one of Williamsburg's four original eighteenth century stores—the others are the Prentis Store, Nicolson Shop and Taliaferro-Cole Shop. *Library of Congress*

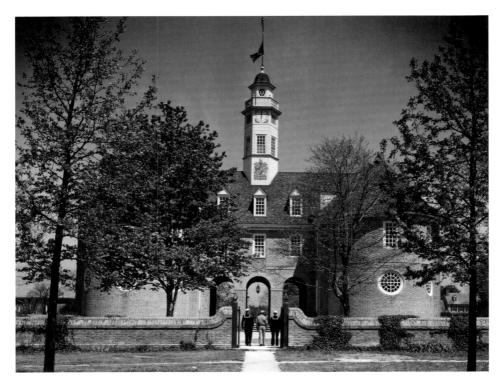

Members of the United States Navy and Army pass the gate of the reconstructed colonial capitol building, photographed in April 1943 by Howard R. Hollem for the United States Office of War Information. *Library of Congress*

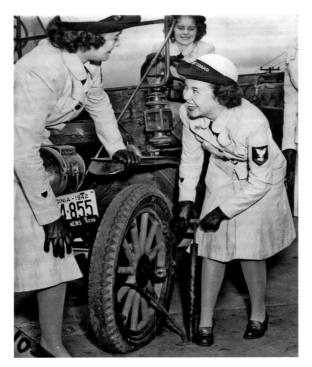

Colonial Williamsburg was a popular tourist attraction for all branches of the military and maritime service during World War II. Here, a group of five United States Coast Guard Women's Reservists, better known as SPARS, from Newport News, Virginia, were smartly clad in new gray-striped seersucker uniforms and ready to set off to visit Williamsburg when a borrowed 1910 Ford Model T got a flat tire. Short of their destination, they took the bus home. The picture was taken on April 7, 1944. *Amy Waters Yarsinske*

The Capitol Restaurant, located on the south side of Duke of Gloucester Street (near the center of Merchants Square), is shown on this postcard dating to in or about 1945. Standing in the doorway is co-owner Tom Baltas. Angelo Costas was Baltas' partner. The restaurant, long gone, is now the Scotland House, Limited. *Amy Waters Yarsinske*

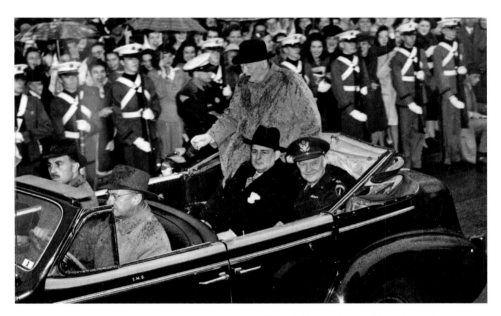

On March 8, 1946, British prime minister Winston Churchill, and General Dwight D. Eisenhower, former Supreme Commander Allied Expeditionary Force and General of the Army, made a nineteen-hour visit to Richmond and Williamsburg that was documented by Richmond photographer Frank A. Dementi. The visit came just three days after Churchill's famous "Iron Curtain" speech at Westminster College in Fulton, Missouri, which marked the onset of the cold war. Churchill, accompanied by his wife, Clementine, and General Eisenhower and his wife, Mamie, began the day with a speech before the General Assembly in Richmond followed by a train trip to Williamsburg. There, they visited the College of William and Mary and Colonial Williamsburg, including drinks and tea at the Raleigh Tavern and dinner at the Williamsburg Inn. In this photograph, Churchill and Eisenhower shared a car in the motorcade headed down Duke of Gloucester Street. *University of Virginia Library*

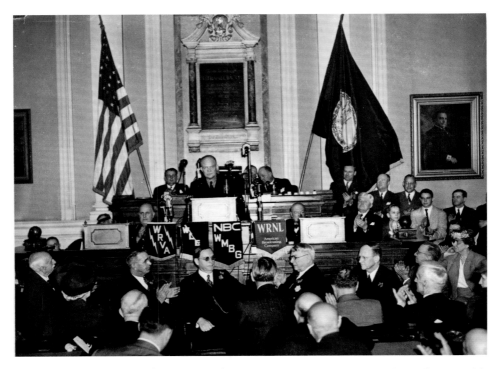

General Dwight Eisenhower (at the podium) made an address at Williamsburg during his joint visit with British prime minister Winston Churchill (seated directly behind Eisenhower) on March 8, 1946. *University of Virginia Library*

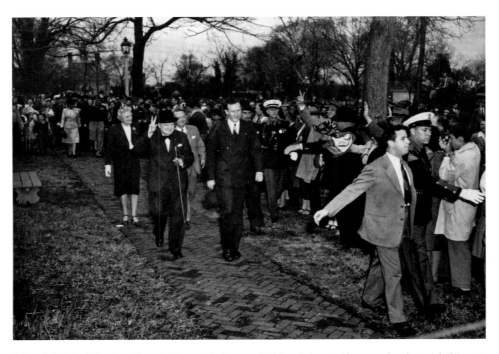

Prime Minister Winston Churchill gave his famous "V" for victory to the crowd as he made his way down the Palace Green on March 8, 1946. *University of Virginia Library*

The Williamsburg Lodge, built by the Colonial Williamsburg Foundation to provide accommodations for visitors to the historic area and shown on this linen period postcard published shortly after it began operation, is located on South England Street and was built between 1937 and 1938, and opened in 1939. The original lodge (pictured here) was a two-story, T-shaped brick hotel facing the historic area to the north and South England Street to the east. *Amy Waters Yarsinske*

While other cities were covering up or ripping out their cobblestone streets, historic Williamsburg put down more. Workmen were photographed on October 8, 1950, setting cobblestones on a section of Francis Street. *Amy Waters Yarsinske*

President Dwight D. Eisenhower flashed his famous grin as he passed between newsmen entering the House of Burgesses chamber of Williamsburg's colonial capitol on May 15, 1953, to commemorate the one hundred seventy-seventh anniversary of the Virginia Resolution for American Independence opening the prelude to independence period in the historic city. Beside him was Winthrop Rockefeller, chairman of the board of Colonial Williamsburg. Speaking briefly, Eisenhower told onlookers: "I wish sincerely that every man, woman and child [who] has the proud privilege of calling himself an American could stand here on this spot [...] and thus regain faith to solve the problems of our day." *Amy Waters Yarsinske*

Queen Mother Elizabeth (second from right with handbag) was greeted by Winthrop Rockefeller (far right), chairman of the board of Colonial Williamsburg, and Kenneth Chorley, president of Colonial Williamsburg, and his wife Jean (standing left of the queen mother), as she entered the Williamsburg Inn on November 10, 1954. The queen mother spent two days of sightseeing around the colonial city. Chorley was involved with the Williamsburg restoration early on. John D. Rockefeller Jr. named the indispensable Chorley his vice president in 1929. *Continued on page 91.*

Continued from page 90: Chorley (1893-1974) had worked for Rockefeller since 1923 and the New York philanthropist and visionary had come to depend on Chorley implicitly not only in matters related to restoration but making Williamsburg a national example of historic preservation. Chorley's role in the revival of Williamsburg, and in the preservation of the cradle of America's history, has been largely forgotten but it should not be—he should be remembered as one of the great and important figures in the restoration undertaken from the 1920s and over which he wielded tremendous influence. *Amy Waters Yarsinske*

The large urns and topiary accents of the ballroom garden at the Governor's Palace were photographed on December 30, 1956. *Amy Waters Yarsinske*

From Colonial Williamsburg records, it is known that during the eighteenth century, the town had six millinery shops, all run by women. Margaret Hunter was one of those women. Though there is little detail available about Hunter's life, she is believed to have come to the colonial town in 1767, and worked in her sister Jane's shop until 1771, when she advertised her own place of business. Hunter had worked in the millinery business in England prior to coming to America. Information is limited but Hunter apparently remained in business until 1780, the year she ran her last advertisement, and after this date nothing more is known about her except that she died seven years later, in 1787. Today's Margaret Hunter Millinery Shop moved into its Duke of Gloucester Street storefront in 1954 and is featured on this postcard in or about 1960. *Amy Waters Yarsinske*

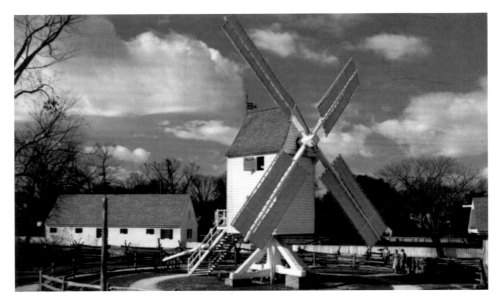

The subject of countless postcards, publications and even a 1980 United States postage stamp, Colonial Williamsburg's post windmill (also called William Robertson's windmill) is shown on this postcard, published shortly after the mill was erected in 1957 behind the Peyton Randolph House to commemorate the sesquicentennial of the Jamestown settlement. This popular destination point in Colonial Williamsburg was based on the 1636 Bourn Mill in Cambridgeshire, England. The defining feature of a post windmill is that the whole body of the mill that houses the machinery is mounted on a single vertical post, around which it can be turned to bring the sails into the wind. Unfortunately, less than 50 years later, the Williamsburg mill stopped working due to mechanical problems and it closed to visitors in 2003. *Amy Waters Yarsinske*

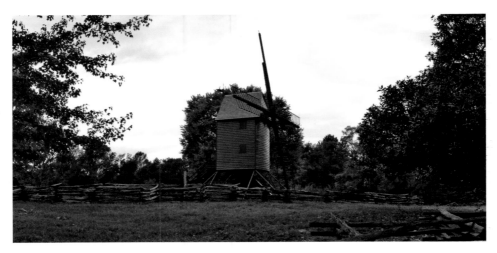

Seven years after the iconic Colonial Williamsburg windmill was closed to the public, in 2010, the mill was dismantled and moved to the east pasture at Great Hopes Plantation, where it was reinforced and restored. The windmill has been permanently collocated with the plantation, a recreation of a typical eighteenth-century Virginia family farm that stands off Visitor Center Drive. The majority of restoration work was completed in the fall of 2015. The windmill has also gotten a makeover. To make it historically accurate, a rust-red, iron oxide tar paint has replaced the white paint seen above. The windmill, photographed on September 11, 2016, is the only one of its type in operation in the eastern United States. *Elizabeth Rowe*[26]

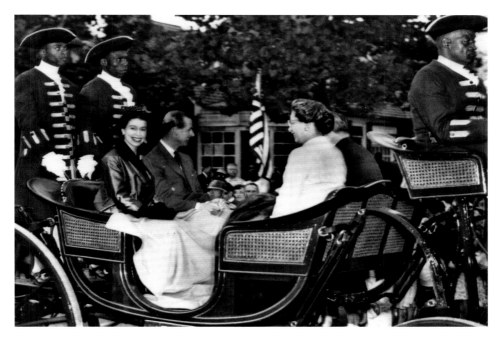

Queen Elizabeth II (left) and Prince Philip ride in a horse-drawn carriage along the Duke of Gloucester parade route after their arrival from Jamestown, Virginia, on October 16, 1957. *Amy Waters Yarsinske*

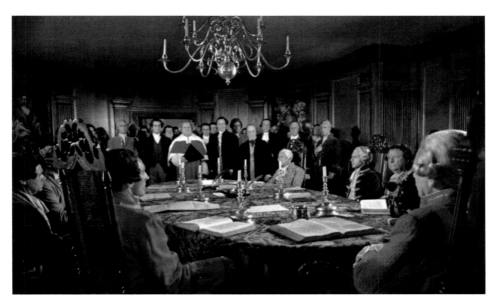

In this scene from the Paramount Pictures and Colonial Williamsburg Foundation orientation film *Williamsburg: the Story of a Patriot* (1957), the royal governor of Virginia, from the council chamber of the colonial capital building, dissolves the Virginia General Assembly. The capitol, reconstructed to its eighteenth-century appearance, was used to film what subsequently became the longest-running motion picture in history, having been shown continually in the Colonial Williamsburg visitor center for decades to follow. The movie was filmed in May 1956 in VistaVision, a high-definition widescreen process with roughly the same negative size as 35-millimeter still photography. This picture, from the film, appeared on a period postcard. The film was subsequently restored and rereleased in 2004. *Amy Waters Yarsinske*

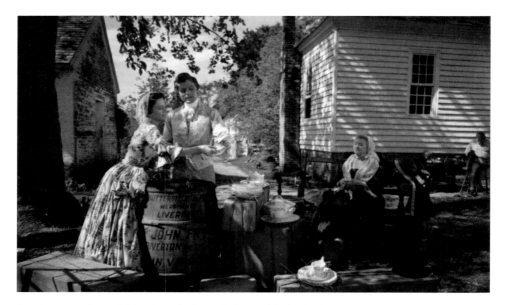

Another scene from *Williamsburg: the Story of a Patriot* (1957), also from a period postcard, depicts the Fry family at Riverton. The film tells the story of Virginia's role in American Independence (up to the point of voting to propose independence at the Second Continental Congress, from the point of view of John Fry (played by a young Jack Lord, shown here), a fictional Virginia planter elected to the House of Burgesses. Though the film was shot almost entirely in and around Colonial Williamsburg and spotlights many of the historic buildings by name, it is a fictionalized dramatization rather than a documentary drama (also known as a docudrama) that features dramatized re-enactments of actual events, adhering to historical facts and often featuring the dialogue of actual real-life persons from available documentation. *Amy Waters Yarsinske*

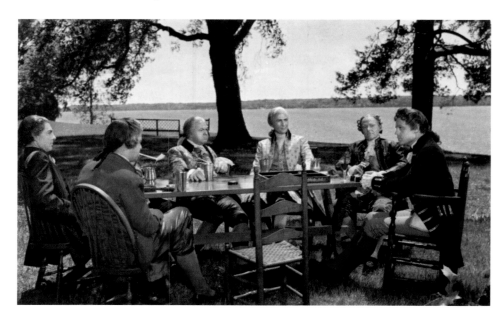

This postcard scene from *Williamsburg: the Story of a Patriot* depicts British sympathizers meeting at Westover Plantation, the home of William Byrd III located thirty-five miles from Williamsburg, and features Jack Lord as John Fry (seated far right, blue coat). *Amy Waters Yarsinske*

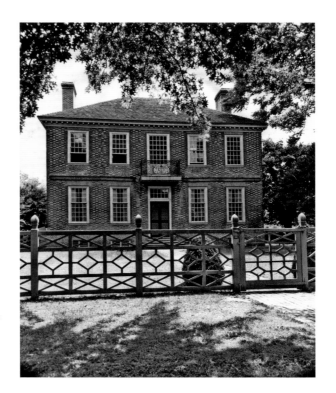

The Allen-Byrd house (also known as the Philip Lightfoot III House) on Francis Street was evidently built sometime prior to 1770 by Surry County planter William Allen. William Byrd III, of Westover in Charles City County, bought the property from Allen, who advertised it for sale that year in the *Virginia Gazette*, a fact that is known from Byrd's will dated July 6, 1774, in which he provided that his house in Williamsburg be sold to pay William Allen for it. The house was photographed on March 10, 1962. *Amy Waters Yarsinske*

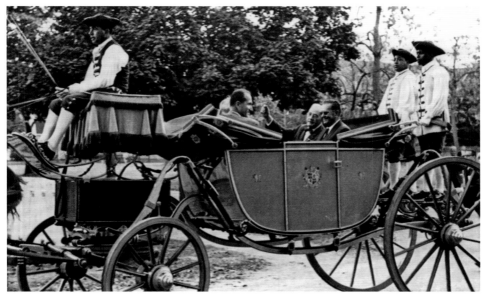

President Josip Broz Tito (1892-1980) arrived on an informal tour of the United States from October 16-25, 1963, coming first to Williamsburg, Virginia. Tito is shown here seated in the back of the carriage (right) on the day of his arrival. Others in his party included (left to right): Yugoslavian major general Luka Božović, adjutant to Tito from 1961 to 1966, and Williamsburg mayor Dr. Henry Morris Stryker (1896-1974). Sitting next to Božović and out of view is Colonial Williamsburg president Carlisle Hubbard Humelsine (1915-1989). Tito fell ill in Williamsburg, recuperating in a bedroom on the second floor of the Allen-Byrd House. *Amy Waters Yarsinske*

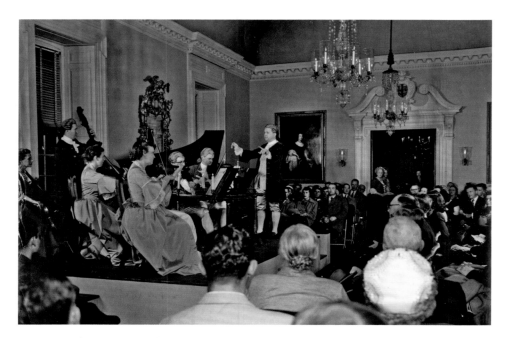

Musicians adorned in period costume and powdered wigs played a concert by candlelight in the ballroom of the Governor's Palace on August 30, 1964. *Amy Waters Yarsinske*

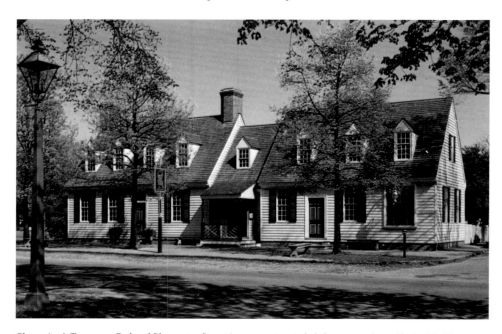

Chowning's Tavern on Duke of Gloucester Street is a reconstructed ale house conducted by Josiah Chowning during the second half of the eighteenth century; it consists of two buildings shown on the Frenchman's Map joined together by an intermediate line, where now is located the principal entrance to the building group. The tavern and outbuildings were reconstructed on old foundations discovered by archaeological excavations on the site of the twentieth century Williamsburg Inn Annex. Archaeological digging on the location was carried on under the direction of the architects of Colonial Williamsburg during 1939. The reconstruction was completed in 1941. This early chrome postcard dates to 1965. *Amy Waters Yarsinske*

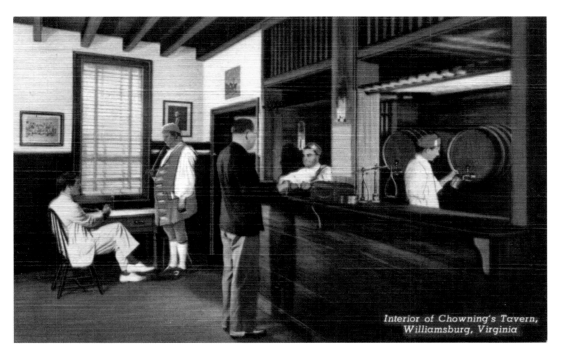

This linen postcard, dating to 1945, shows the Chowning's Tavern tap room. *Amy Waters Yarsinske*

The Elkanah Deane House, located along Prince George Street between Palace Street and a large ravine east of North Nassau Street, has a magnificent formal garden that is characteristic of the landscape with and around restored and rebuilt eighteenth-century Williamsburg homes. The Deane garden is juxtaposed between the house and a gravel driveway leading to the Robert Carter stable and chariot house. This view of the Deane garden from the east, with the Deane house and kitchen in the background, was photographed on March 23, 1965. Elkanah Deane, who acquired the property in 1772 and on which he built a house and outbuildings to include his shop, was the coachmaker of Williamsburg. *Amy Waters Yarsinske*

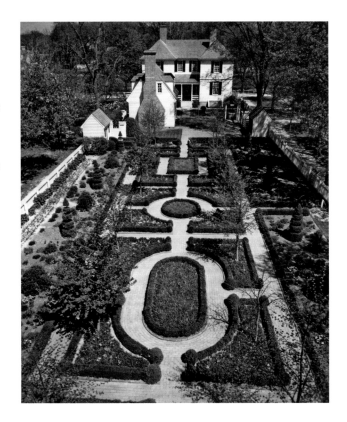

Graham Hood (pictured here in this May 30, 1987 press photograph), a young English art historian who arrived in the historic Virginia enclave in 1971 and eventually took over as chief curator before his retirement, exacted profound change on Colonial Williamsburg and in virtually every other historic site and decorative arts museum in the United States. "For all their grace and splendor, [...] [what was the historic town when he arrived had] seldom reached beyond twentieth-century connoisseurship to explore the lives of the eighteenth-century people who had actually used them," according to an article about Hood in the February 9, 1998 *Daily Press*.[27] Hood's passion for decorative arts, for interpreting the lives of the people who had once lived among the town's restored historic buildings, and his ability (often hard fought) to turn the foundation's emphasis from restoration to conservation and discovery left a monumental impact on the attraction seen by millions each year. *Amy Waters Yarsinske*

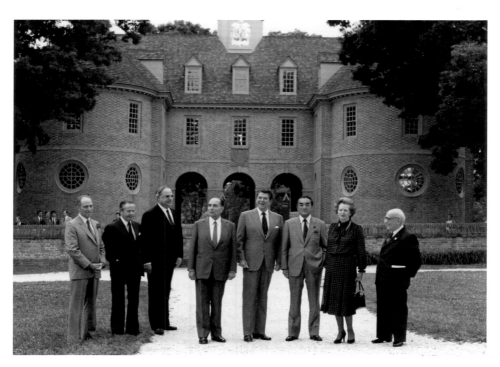

Pictured at the G-7 Economic Summit on May 29, 1983, standing left to right in front of the recreated Williamsburg, Virginia colonial capitol are Prime Minister Pierre Trudeau (Canada), President Gaston Thorn (European Commission), Chancellor Helmut Kohl (Germany), President François Mitterrand (France), President Ronald Reagan (United States), Prime Minister Yasuhiro Nakasone (Japan), Prime Minister Margaret Thatcher (United Kingdom), and Prime Minister Amintore Fanfani (Italy). *Ronald Reagan Presidential Library, National Archives*

This Lion Rampant sign was photographed by Katie Armstrong on May 29, 2004, outside the Red Lion Inn on Duke of Gloucester Street. Built in or about 1719, it was one of Williamsburg's first public houses. Today, it is a private residence. *National Archives*

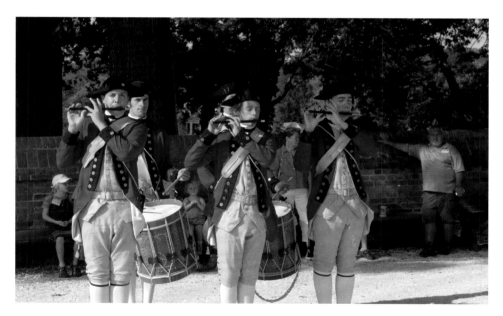

The Colonial Williamsburg Fifes and Drums—also known as the Field Music of the Virginia State Garrison Regiment—carries forward the tradition of military music. Today, just as they were at the onset of the war in 1775, members are ages ten to eighteen. Since 1958 visitors to the city have enjoyed the musical performances and experienced the history of America's Revolution. According to the foundation's history of this esteemed regiment, the Fifes and Drums draw from a waiting list of young community applicants. Accordingly, boys and girls begin their education in military music at age ten and practice weekly for the next eight years, until after they have graduated from high school. These young people talk with the public about the role of music in the eighteenth-century military. They teach younger members the music and history lessons needed to continue the tradition of the field musicians. The picture was taken on September 4, 2007. *National Archives*

Secretary of Defense Robert M. Gates (left) met with retired Supreme Court Justice Sandra Day O'Connor during the World Forum on the Future of Democracy held at the College of William and Mary and Colonial Williamsburg from September 16-19, 2007. Cherie A. Thurlby took the photograph of Gates and O'Connor on September 17, the day that Gates delivered the keynote address at a luncheon at the Williamsburg Lodge. *Department of Defense*

This statue of John Marshall and George Wythe stands at the entrance to the College of William and Mary Marshall-Wythe School of Law, the oldest law school in the United States. Dedicated on October 7, 2000, it honors George Wythe, best remembered as the first professor of law in America and a prominent lawyer and statesman before joining the faculty of the college in 1779, and John Marshall, the chief justice of the Supreme Court for a remarkable thirty-four-year term and who transformed the judiciary's role in the structure of American government. The statue was commissioned by William and Mary alumni Robert Friend and Sara Miller Boyd and wrought by sculptor Gordon Kray, who also fashioned the replica of Lord Botetourt in front of the Wren Building. The picture shown here was taken on November 8, 2007.[28]

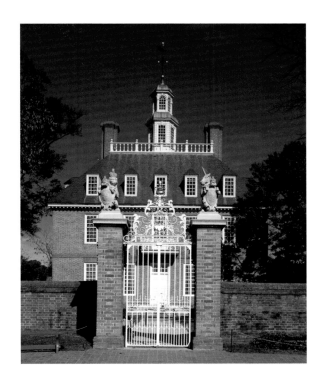

Carol M. Highsmith took this photograph
of the Governor's Palace on July 30, 2011.
Library of Congress

Vice President of the United States Richard Cheney (left) talks with David Addington, Cheney's legal counsel
and chief of staff, upon his arrival at the Governor's Palace on May 4, 2007, during Queen Elizabeth II's visit
to commemorate the quadricentennial anniversary of the first English settlement at Jamestown, Virginia.
National Archives

According to the College of William and Mary, plans in the early 1960s called for construction of a new library on the site of Crim Dell. Fortunately, college president Davis Young Paschall (1960-1971) intervened and the new Earl Gregg Swem Library was instead built at the center of what was then dubbed the "new campus." Paschall later presided over the official dedication of Crim Dell in May 1966, the area named in memory of John W. H. Crim, class of 1901, "who loved the College." The Crim Dell Bridge (shown in this April 23, 2008 photograph) was a gift from the class of 1964. According to campus lore, two people crossing the bridge while holding hands will be lifelong friends, and if they kiss, lifelong lovers. The bridge is the most photographed—and romantic—spot on the college campus.[29]

This life-size bronze sculpture of Thomas Jefferson, located outside the Williamsburg Theater in Merchants Square, was unveiled by the Colonial Williamsburg Foundation and the College of William and Mary on October 28, 1999. Colorado sculptor George Lundeens, who also made the statue of Benjamin Franklin at the University of Pennsylvania, was commissioned to make the sculpture of Jefferson. This Founding Father and third president of the United States sits on a stone bench with a draft of the Declaration of Independence on his writing desk. The sculpture was the gift of Douglas Morton, a William and Mary alumnus, and his wife, Marilyn Brown, both of who served on the college's president's council and were recognized, just then, as members of the Raleigh Tavern Society, a group of the foundation's top donors. Serge Melki, of Indianapolis, Indiana, took the picture shown here on May 28, 2010. *Serge Melki*[30]

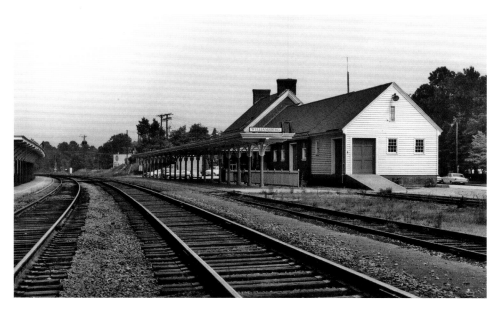

The Williamsburg Chesapeake and Ohio (C & O) passenger station (shown here) was photographed on June 28, 1971, by Clinton L. Andrews. *Amy Waters Yarsinske*

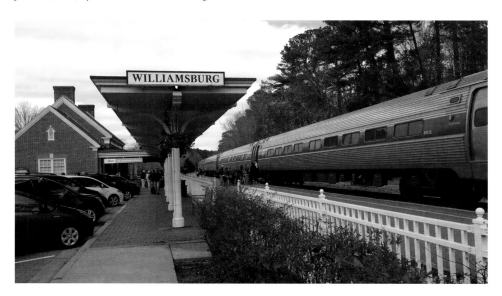

After the Colonial Williamsburg restoration necessitated the closure of the 1907 brick train station formerly behind the Governor's Palace, a newer one (shown here) was built in 1935 on North Boundary Street with funding from John D. Rockefeller Jr. from his project funding. Though passenger rail waned by the 1960s, it was saved when, in 1970, the United States Congress passed and President Richard M. Nixon signed into law, the Rail Passenger Service Act. Proponents of the bill, led by the National Association of Railroad Passengers (NARP), sought government funding to assure the continuation of passenger trains. They conceived the National Railroad Passenger Corporation (NRPC), a hybrid public-private entity that would receive taxpayer funding and assume operation of intercity passenger trains. The NRPC subsequently began operating under the now familiar name of Amtrak. The remaining Chesapeake and Ohio (C & O) passenger service to Williamsburg was replaced in 1971 by Amtrak services. This photograph was taken on March 28, 2015. *Smash the Iron Cage*[31]

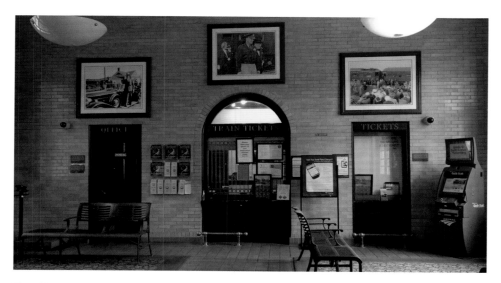

The 1935 brick colonial style Williamsburg train station (now called the Williamsburg Transportation Center) is located directly behind the municipal building and the fire station. During the heyday of the railroads, dozens of dignitaries arrived there, including Presidents Franklin D. Roosevelt, Harry S. Truman and Dwight D. Eisenhower, as well as British prime minister Winston Churchill, some of them prominently featured in large photographs on the walls of the station lobby (shown here). The city of Williamsburg purchased the property from Colonial Williamsburg in 2000. The architectural group of Guernsey Tingle was hired by the city to renovate and restore the building while still maintaining the character and charm of the original structure. The picture was taken on March 28, 2015. *Smash the Iron Cage*[32]

After receiving permission from the county court, a small group of Presbyterians began worshipping at a meeting house in Williamsburg in 1765. Besides Bruton Parish Church, this meeting house was the only authorized place of worship in Williamsburg before the American Revolution. *"We intend to make use of a House in the City of Williamsburgh Situate on part of a Lott belonging to Mr. George Davenport as a place for the Public Worship of God according to the Practise of Protestant Dissenters of the Presbyterian denomination ... "* reads the historic marker adjacent to the building. The photograph was taken on March 28, 2015. *Smash the Iron Cage*[33]

On a magical evening in Colonial Williamsburg, the holiday spirit shines as brightly as each of the twinkling lights adorning the historic Williamsburg Inn, photographed in December 2007. *National Archives*

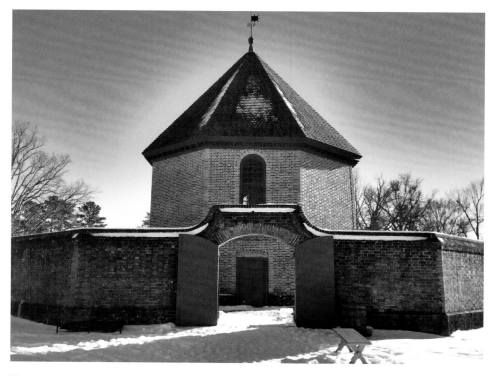

The powder magazine was photographed on January 30, 2014, by David Broad. *David Broad*[34]

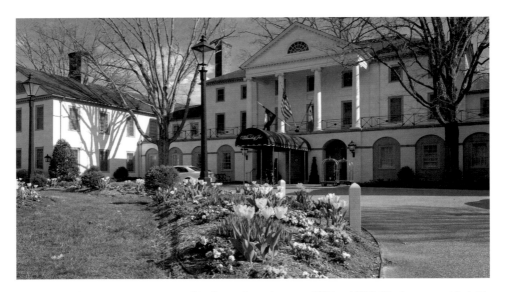

The Williamsburg Inn was constructed in three phases between 1937 and 1972. The large resort hotel is situated on the southern edge of the restored colonial capital and is bounded on the north by historic properties along Francis Street and on the south by the Golden Horseshoe Club and golf course. The central building, shown in this April 12, 2015 photograph, was completed in 1937 to the designs of Perry, Shaw and Hepburn, the Boston architectural firm engaged by John D. Rockefeller Jr. to supervise the restoration of Williamsburg. The inn has twice hosted Her Majesty Queen Elizabeth II and His Royal Highness Prince Philip, Duke of Edinburgh, in 1957 and 2007, during their visits to Jamestown, Virginia, for the sesquicentennial and quadricentennial anniversaries of the first English settlement in America. *Smash the Iron Cage*[35]

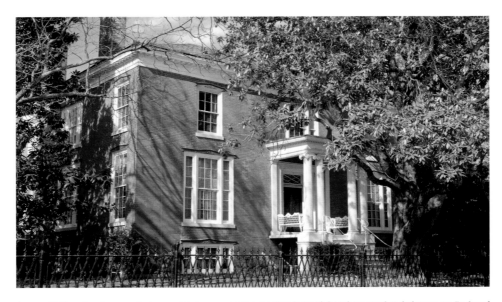

Lemuel J. Bowden, lawyer, judge, and later mayor, began this formal Greek Revival style house on Duke of Gloucester Street in 1858 (shown here as it looked on April 12, 2015). The architect is unknown; however, the contractor was the owner's brother Henry M. Bowden. The residence's Baltimore brick façade and classical inspired white marble porch and steps were unique in Williamsburg. The cornice has been replaced twice, but the rest of the exterior is unchanged, except for a 1967 addition on the rear. In 1875 the house was sold to Robert T. Armistead, and is still in the Armistead family. *Smash the Iron Cage*[36]

The Christmas wreath outside the Margaret Hunter Millinery Shop on Duke of Gloucester Street displayed objects that represented the store's original trade, which extended beyond tailored and specially designed hats and trim to caps, cloaks, aprons and the mantua—a gown. The shop's role today is largely interpretive, showing visitors the trades of the milliner, mantuamaker and tailor. The picture was taken in December 2011. *Albert Herring*[37]

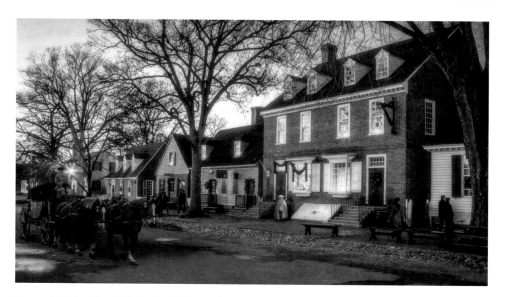

The north side of the 400-block of Duke of Gloucester Street, decorated for the Christmas holiday, was bustling with historical reenactors, tourists and a horse-drawn carriage when Jacob Kurtz took this picture on December 5, 2012. The four buildings from the corner of Botetourt Street (left to right) include Russell House, Margaret Hunter Shop, The Golden Ball, and the double-brick structure divided into the Unicorn's Horn and John Carter's Store, built jointly in 1765 by two brothers—Dr. James Carter, a surgeon and apothecary, and John Carter, a merchant—and destroyed by fire in 1859. The foundation of the Carters' building was discovered during a 1931 excavation and it was subsequently rebuilt. *Jacob Kurtz*[38]

Endnotes

1 By Pascal Auricht [Public domain], via Wikimedia Commons

2 By Michael Kotrady [CC BY-SA 3.0 (http://creativecommons.org/licenses/by-sa/3.0)], via Wikimedia Commons

3 By Michael Kotrady [CC BY-SA 3.0 (http://creativecommons.org/licenses/by-sa/3.0)], via Wikimedia Commons

4 By Harvey Barrison from Massapequa, New York (Colonial Williamsburg uploaded by Albert Herring) [CC BY-SA 2.0 (http://creativecommons.org/licenses/by-sa/2.0)], via Wikimedia Commons

5 By Sarah Stierch [CC BY 4.0 (http://creativecommons.org/licenses/by/4.0)], via Wikimedia Commons

6 By Michael Kotrady [CC BY-SA 3.0 (http://creativecommons.org/licenses/by-sa/3.0)], via Wikimedia Commons

7 By Michael Kotrady [CC BY-SA 3.0 (http://creativecommons.org/licenses/by-sa/3.0)], via Wikimedia Commons

8 Olmert, Michael and Suzanne Coffman. *Official Guide to Colonial Williamsburg.* Williamsburg, Virginia: The Colonial Williamsburg Foundation, 2007.

9 By Smash the Iron Cage [CC BY-SA 4.0 (http://creativecommons.org/licenses/by-sa/4.0)], via Wikimedia Commons

10 By Smash the Iron Cage [CC BY-SA 4.0 (http://creativecommons.org/licenses/by-sa/4.0)], via Wikimedia Commons

11 By Smash the Iron Cage [CC BY-SA 4.0 (http://creativecommons.org/licenses/by-sa/4.0)], via Wikimedia Commons

12 By Smash the Iron Cage [CC BY-SA 4.0 (http://creativecommons.org/licenses/by-sa/4.0)], via Wikimedia Commons

13 By Smash the Iron Cage [CC BY-SA 4.0 (http://creativecommons.org/licenses/by-sa/4.0)], via Wikimedia Commons

14 By Albert Herring [CC BY-SA 3.0 (http://creativecommons.org/licenses/by-sa/3.0)], via Wikimedia Commons

15 By Rob Shenk from Great Falls, Virginia (The George Wythe House uploaded by Morgan Riley) [CC BY-SA 2.0 (http://creativecommons.org/licenses/by-sa/2.0)], via Wikimedia Commons

16 By Smash the Iron Cage [CC BY-SA 4.0 (http://creativecommons.org/licenses/by-sa/4.0)], via Wikimedia Commons

17 By Harvey Barrison from Massapequa, New York (Colonial Williamsburg uploaded by Albert Herring) [CC BY-SA 2.0 (http://creativecommons.org/licenses/by-sa/2.0)], via Wikimedia Commons

18 Coe, Jessica, "Colonial Williamsburg: the corporate town," a project included in the publication "We Doin' Alright: The South in the Great Depression," *Cultural Objects – An Anthology of American Studies*, Volume 5, Spring 1999, published by the American Studies Program, University of Virginia.

19 By Harvey Barrison from Massapequa, New York (Colonial Williamsburg uploaded by Albert Herring) [CC BY-SA 2.0 (http://creativecommons.org/licenses/by-sa/2.0)], via Wikimedia Commons

20 By Harvey Barrison from Massapequa, New York (Colonial Williamsburg uploaded by Albert Herring) [CC BY-SA 2.0 (http://creativecommons.org/licenses/by-sa/2.0)], via Wikimedia Commons

21 By Harvey Barrison from Massapequa, New York (Colonial Williamsburg uploaded by Albert Herring) [CC BY-SA 2.0 (http://creativecommons.org/licenses/by-sa/2.0)], via Wikimedia Commons

22 By Harvey Barrison from Massapequa, New York (Colonial Williamsburg uploaded by Albert Herring) [CC BY-SA 2.0 (http://creativecommons.org/licenses/by-sa/2.0)], via Wikimedia Commons

23 By Harvey Barrison from Massapequa, New York (Colonial Williamsburg uploaded by Albert Herring) [CC BY-SA 2.0 (http://creativecommons.org/licenses/by-sa/2.0)], via Wikimedia Commons

24 By Jrcla2 [Public domain], via Wikimedia Commons

25 By Humberto Moreno (Colonial Williamsburg Uploaded by Albert Herring) [CC BY 2.0 (http://creativecommons.org/licenses/by/2.0)], via Wikimedia Commons

26 By Elizabeth Rowe [CC BY-SA 4.0 (http://creativecommons.org/licenses/by-sa/4.0)], via Wikimedia Commons

27 Erickson, Mark St. John, "High profile: Graham Hood – curious Englishman leaves respected mark in Colonial Williamsburg's history," *Daily Press*, February 9, 1998.

28 By Rpogge (Own work) [Public domain], via Wikimedia Commons

29 By Jrcla2 [Public domain], via Wikimedia Commons

30 By Serge Melki from Indianapolis, USA (Thomas Jefferson - Williamsburg) [CC BY 2.0 (http://creativecommons.org/licenses/by/2.0)], via Wikimedia Commons

31 By Smash the Iron Cage [CC BY-SA 4.0 (http://creativecommons.org/licenses/by-sa/4.0)], via Wikimedia Commons

32 By Smash the Iron Cage [CC BY-SA 4.0 (http://creativecommons.org/licenses/by-sa/4.0)], via Wikimedia Commons

33 By Smash the Iron Cage [CC BY-SA 4.0 (http://creativecommons.org/licenses/by-sa/4.0)], via Wikimedia Commons

34 David Broad [CC BY 3.0 (http://creativecommons.org/licenses/by/3.0)], via Wikimedia Commons

35 By Smash the Iron Cage [CC BY-SA 4.0 (http://creativecommons.org/licenses/by-sa/4.0)], via Wikimedia Commons

36 By Smash the Iron Cage [CC BY-SA 4.0 (http://creativecommons.org/licenses/by-sa/4.0)], via Wikimedia Commons

37 By Albert Herring [CC BY-SA 3.0 (http://creativecommons.org/licenses/by-sa/3.0)], via Wikimedia Commons

38 By Jacob Kurtz [CC BY-SA 4.0 (http://creativecommons.org/licenses/by-sa/4.0)], via Wikimedia Commons

Select Bibliography

Articles, Booklets, Pamphlets And Papers

American Planning Association, "Duke of Gloucester Street: Williamsburg, Virginia," Great Places in America: Streets. https://www.planning.org/greatplaces/streets/2009/dukeofgloucester.htm

Bath, Gerald Horton, "America's Williamsburg: why and how the historic capital of Virginia, oldest and largest of England's thirteen American colonies, has been restored to its eighteenth-century appearance by John D. Rockefeller Jr.," Colonial Williamsburg, Incorporated, 1946.

Butler, Rosanne Thaiss, "The man who said no," *CW Journal*, Autumn 2011. http://www.history.org/Foundation/journal/autumn11/man.cfm

Crews, Edward R., "The millinery shop," Colonial Williamsburg, Winter 1997/98. http://www.history.org/history/clothing/milliner/millinershop.cfm

Daily Press. "Tour: Williamsburg," April 16, 2000. http://articles.dailypress.com/2000-04-16/features/0004150101_1_colonial-williamsburg-foundation-mary-brooke-tucker-family

Heller, Marc, "Behind colonial doors," *Daily Press*, February 9, 1997. http://articles.dailypress.com/1997-02-09/features/9702070112_1_colonial-williamsburg-foundation-restored-area-wayne-williams

Minor, Zak, "Labeling a landmark...or two," *Daily Press*, May 23, 2008. http://articles.dailypress.com/2008-05-23/news/0805210113_1_colonial-williamsburg-intersection-jamestown-college-corner

Molineux, Will, "The Duke of Gloucester Street Special," *CW Journal*, Winter 2012. http://www.history.org/Foundation/journal/winter12/train.cfm

Rouse Jr., Parke, "Carter's Grove bears a special woman's touch," *Daily Press*, March 7, 1993. http://articles.dailypress.com/1993-03-07/news/9303050254_1_restoration-rev-war-goodwin-rockefeller

Straszheim, Deborah, "Jefferson sits in a park," *Daily Press*, October 29, 1999. http://articles.dailypress.com/1999-10-29/news/9910290282_1_mr-jefferson-williamsburg-theater-sit

Tyler, Lyon G., ed., "Diary of John Blair, *William and Mary College Quarterly Historical Magazine*, January 1899, Volume VII, Number 3. http://files.usgwarchives.net/va/schools/wmmary/blair.txt

West, Rachel, "Building a 400-year-old collection of weapons," *Making History*, March 4, 2016. http://makinghistorynow.com/2016/03/building-a-400-year-old-collection-of-weapons/

Books

Brinkley, M. Kent and Gordon W. Chappell. *The Gardens of Colonial Williamsburg*. Williamsburg, Virginia: Colonial Williamsburg Foundation, 1997.

Colonial Williamsburg. *The Official Guidebook of Colonial Williamsburg*. Williamsburg, Virginia: Colonial Williamsburg, Incorporated, 1951.

Kocher, Alois Lawrence and Howard Dearstyne. *Shadows in Silver: A Record of Virginia 1850-1900*. New York: Scribner, 1954.

– . *Colonial Williamsburg: Its Buildings and Gardens*. Williamsburg, Virginia: Colonial Williamsburg Foundation, 1949.

Rouse Jr., Parke. *Tidewater Virginia*. New York: Hastings House, 1968.

Walket Jr., John J. and Thomas K. Ford. *A Window on Williamsburg*. Williamsburg, Virginia: Colonial Williamsburg Foundation, 1973.

Yetter, George Humphrey. *Williamsburg Before and After: The Rebirth of Virginia's Colonial Capital*. Williamsburg, Virginia: Colonial Williamsburg Foundation, 1988.

Websites

College of William and Mary http://www.wm.edu/about/history/historiccampus/

Colonial Williamsburg Foundation http://research.history.org/DigitalLibrary/

Colonial Williamsburg History http://www.history.org/history/index.cfm

Earl Gregg Swem Library, Special Collections Database, College of William and Mary http://scdb.swem.wm.edu/

Franklin D. Roosevelt Day by Day: A Project of the Pare Lorentz Center at the FDR Presidential Library http://www.fdrlibrary.marist.edu/daybyday/resource/october-1934-7/

ABOUT THE AUTHOR

AMY WATERS YARSINSKE is the author of several best-selling, award-winning nonfiction books, most recently *An American in the Basement: The Betrayal of Captain Scott Speicher and the Cover-up of His Death*, which won the Next Generation Indie Book Award for General Non-fiction in 2014. To those who know this prolific author, it's no surprise that this Renaissance woman became a writer. Amy's drive to document and investigate history-shaping stories and people has already led to publication of over 70 nonfiction books, most of them spotlighting current affairs, the military, history and the environment. Amy graduated from Randolph-Macon Woman's College in Lynchburg, Virginia, where she earned her Bachelor of Arts in English and Economics, and the University of Virginia School of Architecture, where she earned her Master of Planning and was a DuPont Fellow and Lawn/Range resident. She also holds numerous graduate certificates, including those earned from the CIVIC Leadership Institute and the Joint Forces Staff College, both headquartered in Norfolk, Virginia. Amy serves on the national board of directors of Honor-Release-Return, Inc. and the National Vietnam and Gulf War Veterans Coalition, where she is also the chairman of the Gulf War Illness Committee. She is a member of the American Society of Journalists and Authors (ASJA), Investigative Reporters and Editors (IRE), Authors Guild and the North Carolina Literary and Historical Association (NCLHA), among her many professional and civic memberships and activities.

If you want to know more about Amy and her books, go to
www.amywatersyarsinske.com